IMAGES
of America

CHICKEN BONE
BEACH

ON THE COVER: Vacationers with blankets and umbrellas enjoy Missouri Avenue Beach, known as Chicken Bone Beach, around 1940. Observe the scenic view of Stars of Radio Stage and Screen Jumbo Circus in the background. (Photograph by John Mosley; courtesy of Charles L. Blockson Afro-American Collection, Temple University.)

IMAGES
of America

CHICKEN BONE
BEACH

Ronald J. Stephens, Henrietta W. Shelton,
and the Chicken Bone Beach
Historical Foundation Inc.
Foreword by Heather Perez

ARCADIA
PUBLISHING

Copyright © 2023 by Ronald J. Stephens, Henrietta W. Shelton, and the Chicken Bone Beach
 Historical Foundation Inc.
ISBN 978-1-4671-0957-4

Published by Arcadia Publishing
Charleston, South Carolina

Printed in the United States of America

Library of Congress Control Number: 2022949906

For all general information, please contact Arcadia Publishing:
Telephone 843-853-2070
Fax 843-853-0044
E-mail sales@arcadiapublishing.com
For customer service and orders:
Toll-Free 1-888-313-2665

Visit us on the Internet at www.arcadiapublishing.com

*We dedicate this book to the contributions of
Victor and Alma Green, John W. Mosley, the lifeguards,
and the workers who cleaned the beaches.*

CONTENTS

FOREWORD

Images of the beach are often about fun—the sand, the sea, the surf. They show families and friends having a good time. While these images show just this on Atlantic City's Missouri Avenue Beach, they also reveal a deeper, nuanced part of the city's history. De facto segregation in most aspects of life in the early 1900s forced Black tourists and residents to avoid the popular Atlantic City Boardwalk establishments and restaurants and instead frequent those in the Northside of Atlantic City, a neighborhood several blocks from the beach. By 1930, this segregation had also expanded to that great outdoor equalizer—the beach. Hoteliers petitioned the city to dedicate an area for Black beachgoers away from the sand in front of their businesses. With the construction of the municipal auditorium—known as Convention Hall and later Boardwalk Hall—the beach in front of the behemoth building was identified as an ideal location. Ironically, this stretch of beach was prime real estate, as it was perfectly situated in the center of the city and was very accessible from the Northside neighborhood. It was close to the entertainment district on North Kentucky Avenue and steps away from the hotels and Boardwalk restaurants where many of the Black residents worked but could not stay or eat.

In *Chicken Bone Beach*, Dr. Ronald J. Stephens and Henrietta Shelton recount the creation of the segregated beach, celebrate the nostalgia of the past, and commemorate the shared history of Black residents and tourists to Atlantic City.

—Heather Perez
Atlantic City historian
Stockton University Special Collections librarian

ACKNOWLEDGMENTS

A partnership agreement was established between Ronald J. Stephens of Purdue University and Henrietta Shelton, president of the Chicken Bone Beach Historical Foundation Inc. (CBBHFI), to produce this publication. As such, we would like to thank Purdue's College of Liberal Arts ASPIRE program for its support as well as past and current board members of CBBHFI for supporting the dream to complete this book. To the individuals who aided and dedicated their expertise with the layout, editing, and technical support to produce this book, we thank you so much for your time, knowledge, and energy. This includes a special thank you to Heather Perez, special collections librarian at the Stockton University Richard E. Bjork Library, and Viola Gray-Hudgins, who assisted with identifying images and writing captions. To the donors of the images we received from former residents—thank you to Sid Trusty (deceased) and Vicki Gold Levi and former Club Harlem showgirls and dancers such as Joan Meyers Brown of Philadelphia and Betty Jo Alvies of New York; your memories and assistance are cherished. Thank you also to the archivists and directors of the archival collections we consulted and from which we retrieved images to produce this book: Leslie Lowry-Willis and Diane D. Turner of Temple University's Charles L. Blockson Afro-American Collection with its invaluable John W. Mosley Photograph Collection; Jacqueline Silver Morillo, archivist of the Atlantic City Free Public Library's Atlantic City Heritage Collections; and Ralph Hunter, founder and curator of the African American Heritage Museum of Southern New Jersey. Finally, we would like to recognize the Donfor family, with a very special thanks to Victoria and Charlene Donfor for sharing images of 1950 and 1960 memories on the sandy Jersey shore.

INTRODUCTION

Ninety years ago, during the Jim Crow era, Atlantic City, New Jersey, was not as hospitable to the thousands of African Americans vacationers as it is today. Bryant Simon in *Boardwalk of Dreams: Atlantic City and the Fate of Urban America* explains how African Americans "could gain full access to the Boardwalk's middle-class utopia only if they could pass as white." Darker-skinned African Americans, unable to pass as white but who could afford to purchase Boardwalk goods and services, were discriminated against by business owners who denied them general services and purchasing rights available to white consumers.

Sometimes African Americans got more than just cold stares if they broke the city's unwritten Jim Crow rules. Police in the 1930s "forcibly eject[ed]" Black families from any beach other than the Black beach, known then as Chicken Bone Beach, located between Mississippi and Missouri Avenues. Throughout most of the 1920s, the city's Black beach had been at Indiana Avenue, but when the Claridge Hotel opened there toward the end of the decade, the owners complained and managed to have African American sunbathers moved a few blocks south of the space in front of Convention Hall and behind a sandstone wall. Black people were at the same time barred from the best seats in movie houses, restaurants, and nightclubs. No Boardwalk store would allow African Americans to try on clothes, no matter how much money they had. While the police might leave well-dressed Black couples on vacation alone on the Boardwalk, they would harass city residents who tried to join the roving fashion show. They did not want them to think they had free access to this public space. White bar owners regularly threw Black men out of their establishments or charged as much for a shot and a beer as a lobster dinner would have cost down the street.

By the late 1920s, a group of hotel owners and politicians passed a city ordinance that would lift restrictions and designate Missouri Avenue Beach (later nicknamed Chicken Bone Beach) as a space for African Americans to enjoy the beach. Before then, they experienced racial discrimination and social isolation. In *Telling the Philadelphia Story*, the curators of a Woodmere Art Museum's 2016 exhibition explain how despite the city's racist past, Chicken Bone Beach (CBB) thrived from 1900 through the early 1950s as "a place where countless [Black] vacationers from Pennsylvania, New York, New Jersey, [Washington, DC, Delaware] and elsewhere enjoyed the pleasures of family and summer fun each year." Upper-middle and middle-class vacationers from the East Coast and Midwest and residents flocked to the sandy New Jersey beach to sun and splash and pose whenever the self-taught photographer John W. Mosley of Philadelphia appeared.

As thousands of vacationing families flocked to the shore with their fried chicken in picnic baskets, a celebratory atmosphere was shared alongside famous Black entertainers, including Sammy Davis Jr., Count Basie, and Sarah Vaughn, and Club Harlem dancers and showgirls. Celebrities such as Rev. Martin Luther King Jr. and the former heavyweight boxing champion Joe Louis also toured the beach and had fun. As revealed in 1997, another Atlantic City ordinance was passed, indicating how long Chicken Bone Beach has survived as a symbol of family unity and African American brother and sisterhood. Today, the site of Chicken Bone Beach is located in front of

what is now Caesars Atlantic City Hotel and Casino and Jim Whelan Boardwalk Hall, which stretches from Mississippi Avenue to Missouri Avenue.

Chicken Book Beach revisits this rich history through pictures with captions in four chapters. In chapter one, "History of Missouri Avenue Beach" we introduce readers to key documents and images that showcase the origins of the beach and the first Black captain of the lifeguards, Capt. William "Rube" Albouy, who managed a patrol of 12 lifeguards to ensure the safety of as many as 5,000 swimmers annually during the summer months and early decades of the beach's history. We also introduce Dr. Russell Jackson, beach patrol doctor, and Capt. Marshal "Chip" Wood, who replaced Captain Albouy.

Chapter two, "Northside Businesses and Neighborhood," explores the history of the neighborhood as the Black Wall Street of the North during the late 1800s and the Great Migration where African Americans came to build hotels, the Boardwalk, and railroads. Some migrants from Georgia, Alabama, and Mississippi came and found the hospitality industry inviting, with better job opportunities than picking cotton in the South, like working as hotel cleaners, bellhops, and waiters. The area of the city where African Americans were forced to live and work was on the Northside on streets between Connecticut Avenue to Arkansas Avenue to Atlantic City and to the outskirts of Venice Park. Images of the board of trade, Fitzgerald Auditorium, and successful Black entrepreneurs, including millionaire "Madame" Sara Spencer Washington of Washington's Apex Beauty College and 12 other millionaires, as well as over 137 business owners, such as hotel and bar owners Reggie Edgehill and Isaac Nicholson, an ice company, florist, dry cleaners, restaurants, barbershops, Newsome's Beauty Salon, Johnson's Garage, rental cottages, churches, funeral parlors, and grocery stores with 42 liquor licenses are shared from the 1930s to early 1960s. Horace Bryant, who founded the credit union to grant loans to families wanting to buy homes and individuals seeking to establish their businesses, such Dick Austin, a businessman who ran a rose garden, and other forerunners of the community, such as Maggie Creswell, one of the first female police officer in New Jersey, are displayed here.

Then, in chapter three, "Atlantic City in the Civil Rights Movement," we include early images of the civil rights movement era in Atlantic City, as well as the nightclubs on Kentucky Avenue and lavish musical productions appearing at Club Harlem. This includes images of the club's staff, dancers, showgirls, and special appearances of Sammy Davis Jr. alongside them.

Complimenting this history, chapter four, "Honoring History: Chicken Bone Beach Historical Foundation Inc.," captures another transitional period in the community as CBBHFI was founded and championed projects to renew interest in the cultural and musical history of the area, including more than 25 years of free jazz concerts, the renovation of the Chicken Bone Beach Youth Institute for Jazz Studies House through the generous support of City of Atlantic City Community Development Block Grant, the Casino Reinvestment Development Authority, and New Jersey State institutions, corporations, and private donors. The 2022 NAACP Convention sponsored a reenactment of performances of entertainment held at the famous Club Harlem and celebration on the beach, and images of the students and their instructors appearing during rehearsals are shared.

One

HISTORY OF
MISSOURI AVENUE BEACH

The story of Missouri Avenue Beach and the role it served in the life of the African American community in Atlantic City deserves attention because it represents a missing link in the narrative about Black vacationing in the United States. The beach was a racially segregated section of the Atlantic City beach between Missouri and Mississippi Avenues. The nickname, Chicken Bone Beach, was derived affectionately from the tradition of the thousands of vacationing families who annually flocked to the shoreline bringing beach balls, umbrellas and blankets, and picnic baskets with fried chicken and other delights for seaside dining and oceanside fun. This beach, which became an oasis, was known for attracting African American locals and touring vacationers, entertainers, and celebrities. Often chicken bones were left in the sand.

The conditions under which Chicken Bone Beach existed include Jim Crow segregation as travelers used Victor Green's *The Negro Motorist Green-Book* to identify friendly eating, lodging, and gas stations; the emergence of old and new African American middle-class families; the availability of the automobile, which signified freedom for African Americans; and the rise of Black-owned and -operated businesses in East Coast urban cities in America.

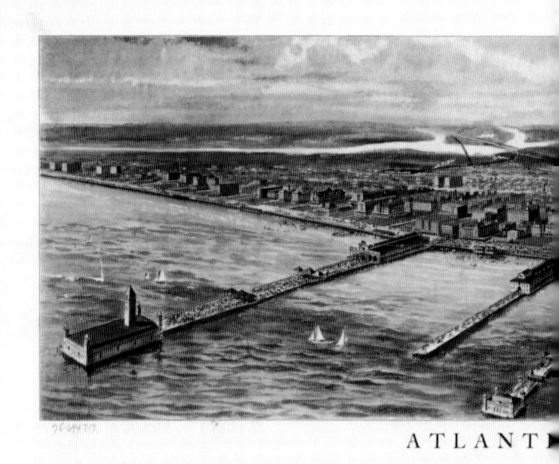

A T L A N T I

Atlantic City is located on Absecon Island and was founded in 1854. As a barrier island, the beaches are all located on the Atlantic Ocean side of the island along with the entertainment piers,

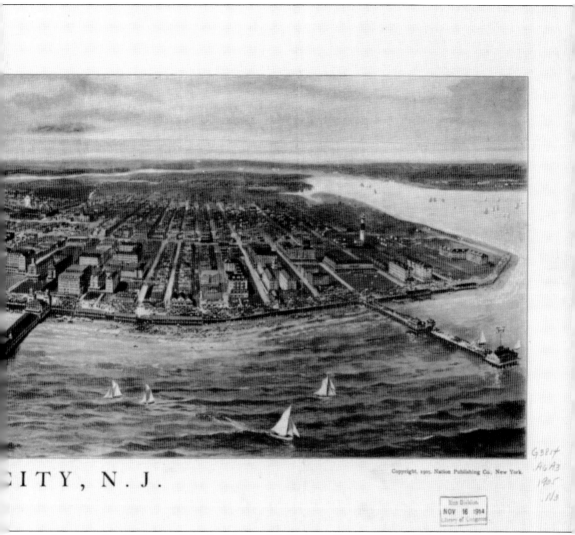

:ITY, N.J.

as shown in this 1905 map. (Map by National Publishing Co.; courtesy of Library of Congress.)

African Americans benefited from various sponsored excursions to the shore. This image is of the 1910 Grand Army of the Republic (GAR) Encampment, which was held in Atlantic City. (Photograph by William Rau; courtesy of the Vicki Gold Levi collection, Atlantic City Heritage Collections, Atlantic City Free Public Library.)

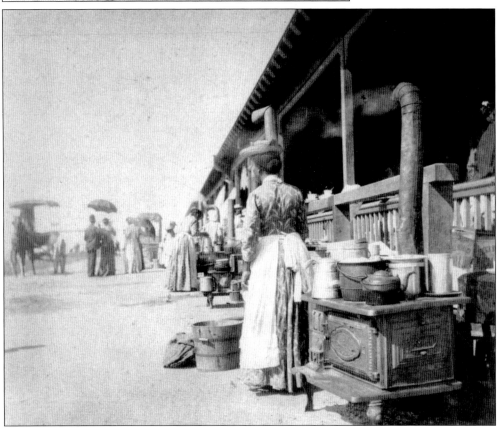

This woman attended the 1910 GAR Encampment and cooked at the outdoor pavilion located in the inlet area of Atlantic City, on the northern tip of Absecon Island. (Photograph by William Rau; courtesy of the Vicki Gold Levi collection, Atlantic City Heritage Collections, Atlantic City Free Public Library.)

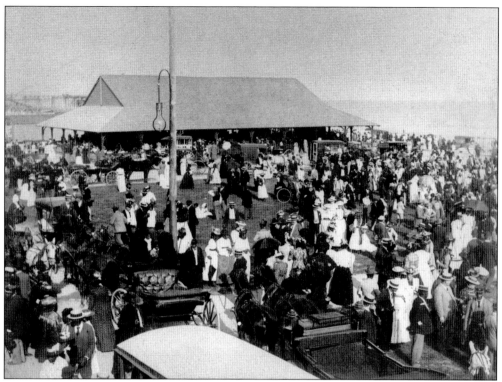

The attendees at the GAR Encampment were veterans of the Union army during the Civil War. They came with their families to Atlantic City for the reunion. (Photograph by William Rau; from the collection of Vicki Gold Levi, courtesy of Atlantic City Heritage Collections, Atlantic City Free Public Library.)

GAR Encampment members frolic in the ocean in 1910. Note the two women in bathing dresses as well as the man in a hat. (Photograph by William Rau; from the collection of Vicki Gold Levi, courtesy of Atlantic City Heritage Collections, Atlantic City Free Public Library.)

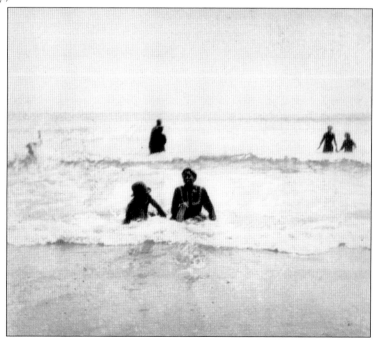

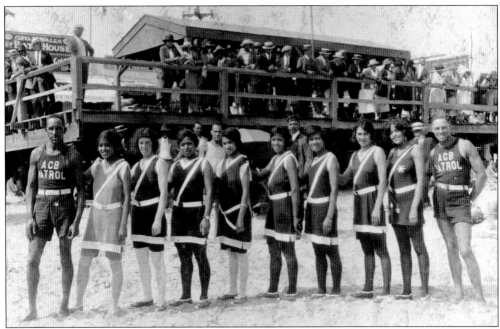

At the other end of Atlantic City at Texas Avenue, George Walls opened the first known Black-owned business on the Boardwalk as early as 1896. His bathhouse rented bathing suits and changing stalls for people to utilize to enjoy the beach. The Walls family was one of the most prominent African American families in the city in the early 20th century. In the 1920s, Walls sponsored a float in the Miss America Pageant, and these ladies and Atlantic City Beach Patrol guards participated in the event. (Courtesy of Atlantic City Heritage Collections, Atlantic City Free Public Library.)

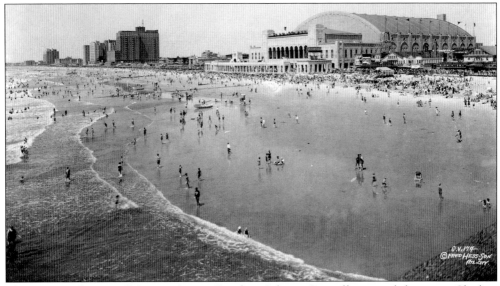

This is an aerial image of Missouri Avenue Beach in Atlantic City, affectionately known as Chicken Bone Beach by the African American community from the 1930s to the 1960s. This c. 1940 image is of so many vacationers exploring the sand and the sea in front of Atlantic City's Convention Hall. (Courtesy of Atlantic City Heritage Collections, Atlantic City Free Public Library.)

Women's bathing suits of the era were more like dresses and required stockings and caps, like the one on this woman wading in shallow water in 1921. (Courtesy of Atlantic City Heritage Collections, Atlantic City Free Public Library.)

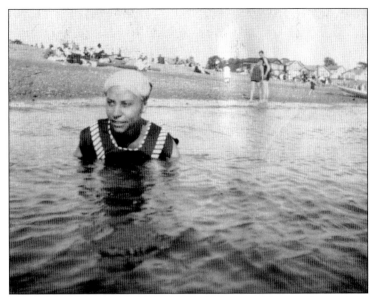

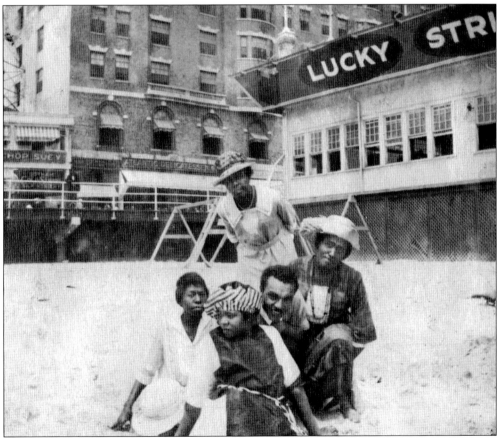

This well-dressed group on the beach poses in front of the Lucky Strike Cigarette sign, with Boardwalk shops in the background, around 1921. (Courtesy of Atlantic City Heritage Collections, Atlantic City Free Public Library.)

PENNSYLVANIA AVENUE AND THE BOARDWALK

THOMAS E. RANDOW
MANAGER

H. BRADFORD RICHMOND
PROPRIETOR

ON THE BEACH
ALWAYS OPEN
SEA WATER BATHS
FIREPROOF GARAGE

CAPACITY 600
FIRE PROOF
AMERICAN PLAN
EUROPEAN PLAN

HOTEL STRAND

ATLANTIC CITY, N.J.

EXECUTIVE OFFICE

Copy to Director Cuthbert

August 14, 1928

Hon. A. M. Ruffu, Mayor,
City Hall,
Atlantic City, N.J.

My dear Mayor Ruffu:

On Tuesday evening, August 7, I was invited
to attend a meeting at The Seaview Golf Club to discuss the
1929 program for advertising Atlantic City.
There were thirty five men there. Every beach front hotel
proprietor and Avenue hotel proprietor, together with several
merchants and bankers who contribute to the annual
Combination Advertising Fund were there.
Mr. Frank Irving Fletcher who writes the advertising copy
for us, and who wrote the attached copy, was there also as a
guest.

Instead of the meeting being devoted entirely
to the subject upon which we were called together to discuss,
it immediately developed into a general discussion upon the
colored bathing situation of Atlantic City and what should be
done about it before any additional funds are spent.

Those of us who have been in touch with you on
this subject spoke on your proposal of Texas Avenue.
Everyone there, almost to a man, said this place was inadequate.
Everyone there was of the same opinion that it was up to you
and the City Commissioners to solve this problem and to set aside
a bathing beach of sufficient size and attraction to take care of
them as is done in other cities.

As I have outlined to you on several occasions,
you should assign the bath house under the Convention Hall at
Georgia Avenue and the beach. This would give them fine ac-
commodations. The beach is wide and high there and I feel sure
that all sensible colored persons either visitors to Atlantic City
or those employed here would be perfectly willing to go there.
As it is now - they are strung all along our beaches from

In 1928, the beachfront hotel directors met at the Seaview Golf Club to discuss the 1929 program for advertising Atlantic City and to draft a letter to Atlantic City mayor Anthony Ruffu Jr. regarding the colored bathing beach location. (Courtesy of Bryant Simon.)

HOTEL STRAND

ATLANTIC CITY, N.J.

EXECUTIVE OFFICE
#2-Hon.A.M.R.

Pennsylvania Avenue to Arkansas Avenue, centralizing in such spots as North Carolina, Indiana, Park Place, Ohio and Michigan Avenues. Many bathers are now seen parading the Boardwalk in suits covered sparingly with cheap make-shift coverings, dripping wet sand on the Boardwalk and brushing shoulders with well dressed men and women - quite a few of whom have complained to me and to others that I personally know of.

I can cite many instances of valuable summer business lost to Atlantic City through this lack of proper handling of the subject. I know now of nine families of wealth who formerly spent August and early September here who do not come here now for the very reason that they will not bathe side by side with colored bathers.
Continue to drive away the wealth from any community and see just how long that community will live and thrive and prosper.

Some afternoon walk down the Boardwalk from the Steeplechase Pier to the Million Dollar Pier and see for yourself.

Many hotel men have spoken of changing from colored to white help as a solution of the problem.
To my mind, this is not the way to solve it.
I have spoken to many colored persons on the subject and they are all willing to go to a well regulated and properly conducted beach such as you provide for white people.

I feel sure the beach in front of the Convention Hall would solve the problem and I want to go on record with you and the Commission as one who (as a substantial tax payer) is in favor of assigning the beach in front of the Convention Hall as a Municipal colored bathing beach,

Yours sincerely,

HBR▼M

H Bradford Richmond

They requested the creation of a segregated beach for African Americans in front of the under-construction Convention Hall. (Courtesy of Bryant Simon.)

CABLE ADDRESS AMBASSADOR

THE AMBASSADOR

ATLANTIC CITY, N.J.

August 16, 1928.

OWNED AND OPERATED BY THE AMBASSADOR HOTELS SYSTEM

Hon. William Cuthbert,
City Hall,
Local.

My dear Mr. Cuthbert:-

At a recent meeting of the Hotel Men, the
matter of colored bathing was taken up and it was
the consensus of opinion that the selection of the
Texas avenue site which is now owned by the city
would not only be extravagant but would also be a
location too far from the center of the city and
that the Georgia Avenue side of the Convention Hall
would be the logical place for a colored bath house.

I am writing to you, also the Mayor and the
Commissioners, and hope that you will use your
good offices in furthering the interests of the
beachfront which I feel is quite vital to the
future success of Atlantic City.

Very truly yours,

ETL:ATM

In this separate 1928 letter to the director of public safety William Cuthbert, another hotel director advocated for the segregated beach, which was established at Missouri Avenue and became Chicken Bone Beach. (Courtesy of Bryant Simon.)

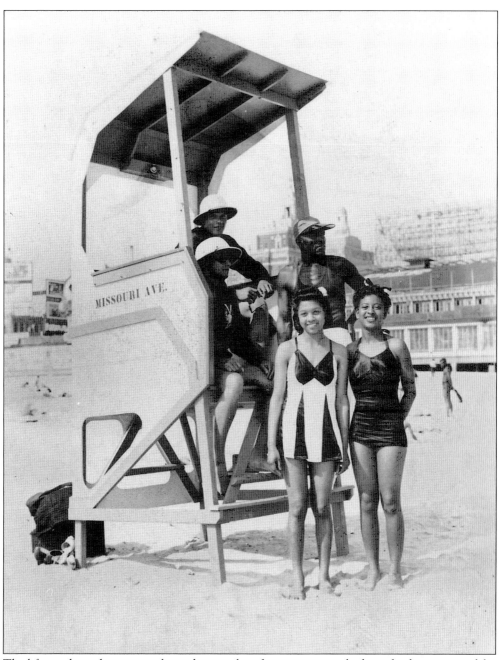

The lifeguard stand was a popular gathering place for vacationers who have fond memories of the guards. The Atlantic City Beach Patrol (ACBP) is the oldest operating lifeguard organization in the United States. In 1855, the city council appointed William Cazier as "Constable of the Surf." (Photograph by John Mosley; courtesy of Charles L. Blockson Afro-American Collection, Temple University.)

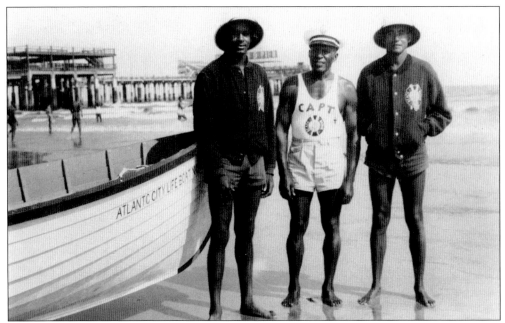

ACBP guards and captains at Missouri Avenue beach were primarily African American. Pictured here are, from left to right, T. Roy Collins, Capt. Rube Albouy, and Robert Fitzgerald. (Photograph by John Mosley; courtesy of Charles L. Blockson Afro-American Collection, Temple University.)

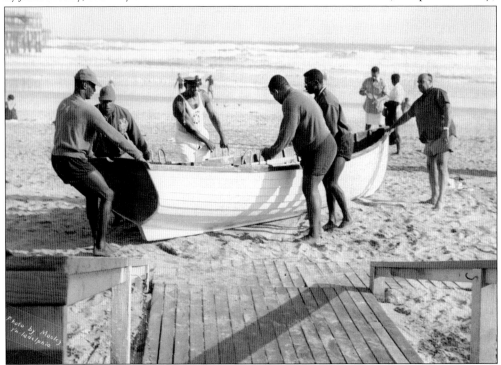

The heavy wooden Van Duyne boats were used on all Atlantic City beaches. Here, the guards work together to pull the boat from the water. (Photograph by John Mosley; courtesy of Charles L. Blockson Afro-American Collection, Temple University.)

In the lifeguard's offices were a medical station and rest area. Here, a child is attended to by Capt. Rube Albouy (sitting) and Dr. Russell Jackson (kneeling). Note the poster in the background advertising a Miss Sepia Summer Season beauty contest in August 1958, headlined by performer Dakota Staton. (Photograph by John Mosley; courtesy of Charles L. Blockson Afro-American Collection, Temple University.)

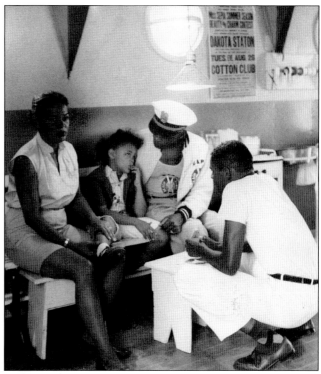

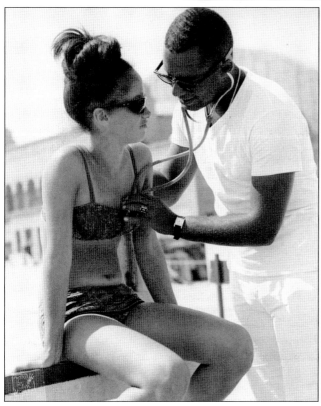

Dr. Russell Jackson checks the heartbeat of one of the young women beachgoers. (Photograph by John Mosley; courtesy of Charles L. Blockson Afro-American Collection, Temple University.)

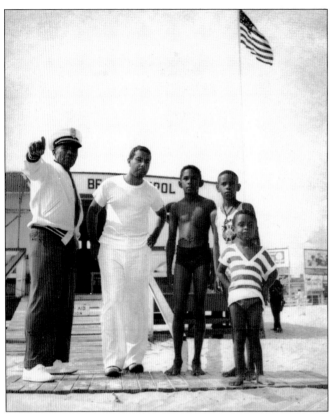

Capt. Rube Albouy directs four young and old Black male vacationers in front of the Atlantic City Beach Patrol offices. (Photograph by John Mosley; courtesy of Charles L. Blockson Afro-American Collection, Temple University.)

Atlantic City Beach Patrol guards are shown with a junior lifeguard. Forty-one guards served on Chicken Bone Beach, including Rube Albouy, Robert Bolden, Mike Brown, Leon Byard, Robert Cash, Damien Cahill, Dean Castellani, William Cheatham, Donald Collins, Teroy Collins, William Demones, George "Buddy" Dickerson, Gene Fetter, Robert Fitzgerald, Ted Gray, Jim Hosick, Robert Howie, Joseph Jacobs, Tom James, Ollie Johnson, William "Billy" Kelly, William "Billy" Lawler, Robert Lashley, Ron Lee, Pat McVey, Al Moss, Robert Peopples, George Peopples, Al Peyton, Kevin Quigley, Ray Shepperson, Anthony Tripician, Steve Voso, and Marshall Wood Jr. Five other guards' names are currently unknown. (Photograph by John Mosley; courtesy of Charles L. Blockson Afro-American Collection, Temple University.)

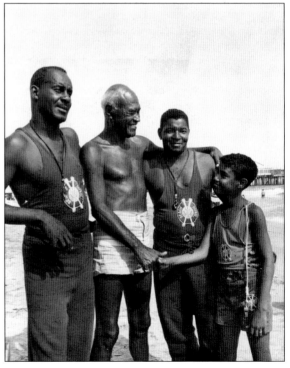

The beach was not only for vacationers. Local residents, including businessman Clifford J. Newsome (center), with Capt. Rube Albouy (left) and T. Roy Collins (right), also frequented the shore. (Photograph by John Mosley; courtesy of Charles L. Blockson Afro-American Collection, Temple University.)

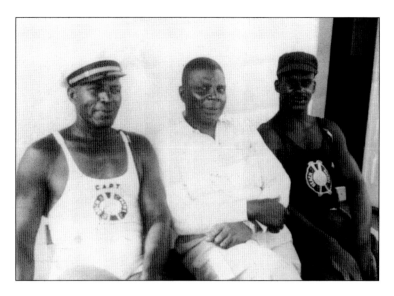

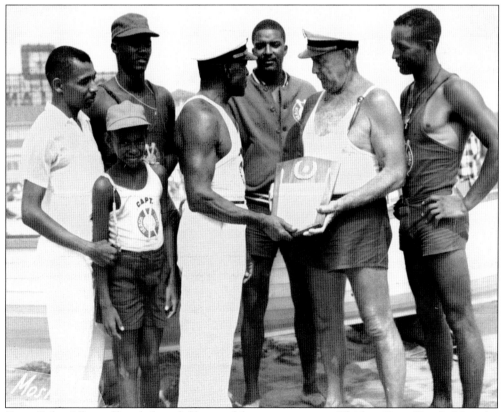

Capt. Rube Albouy (fourth from left) served for many years on Chicken Bone Beach. Here, he receives a plaque commemorating his service. Donald Collins, standing behind the plaque, and other guards look on. (Photograph by John Mosley; courtesy of Charles L. Blockson Afro-American Collection, Temple University.)

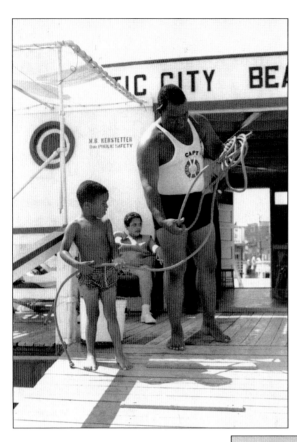

Chicken Bone Beach Atlantic City Beach Patrol captain Marshall D. Wood Jr. and his son Marshall D. "Chip" Wood III are seen here in 1959. (Photograph by John Mosley; courtesy of Charles L. Blockson Afro-American Collection, Temple University.)

The legacy of Chicken Bone Beach is made possible through generational tradition. Here, Capt. Marshall D. Wood Jr., his son Marshall D. Wood III, and Junior's father, Marshal D. Wood, walk along the shore hand in hand in 1959. (Photograph by John Mosley; courtesy of Charles L. Blockson Afro-American Collection, Temple University.)

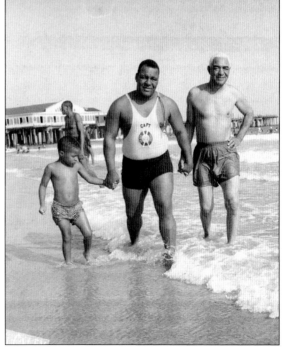

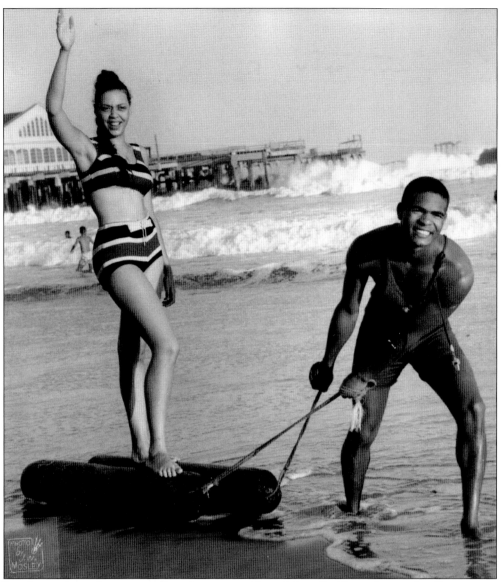

Beach patrol guards are remembered as personable and friendly. Here, the guard pulls a woman posing on rescue floats. (Photograph by John Mosley; courtesy of Charles L. Blockson Afro-American Collection, Temple University.)

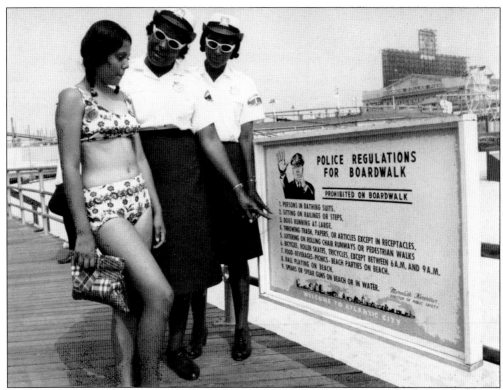

Atlantic City Police matrons had the job of enforcing proper Boardwalk and beach attire. Bathing suits could not be worn on the Boardwalk until the 1960s. Under the strict Mackintosh laws, men had to wear shirts on the beach and in the water until the 1940s and women had to wear stockings and bathing dresses until the late 1920s. To the far right are boardwalk security ladies Frances Tyson and Helen Rogers, who "instruct" a female beachgoer on proper Boardwalk attire. (Photograph by John Mosley; courtesy of Charles L. Blockson Afro-American Collection, Temple University.)

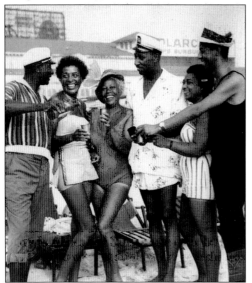

People returned to the beach year after year to enjoy themselves and meet up with friends. Many have fond memories of a man named "Champagne" Frank or George or Ray (far left)—depending on who tells the story—who would always celebrate with bottles of bubbly (Photograph by John Mosley; courtesy of Charles L. Blockson Afro-American Collection, Temple University.)

Four unidentified jolly old-timers are smiling for the camera and having lots of beach fun. (Photograph by John Mosley; courtesy of Charles L. Blockson Afro-American Collection, Temple University.)

Families and friends continued to meet and network at the beach. Billy Strayhorn (center) and his friends, shown here around 1960, are a perfect example. (Photograph by John Mosley; courtesy of Charles L. Blockson Afro-American Collection, Temple University.)

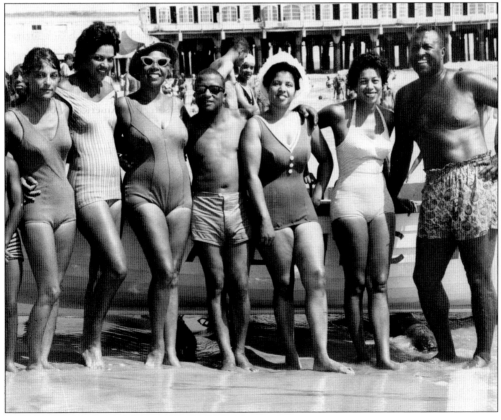

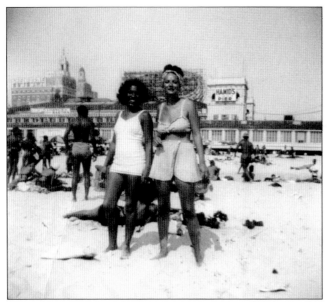

The northern border of Chicken Bone Beach was delineated by Hamid's Dollar Pier. Two ladies pose for a photograph on the beach with the pier in the background. (Courtesy of Atlantic City Heritage Collections, Atlantic City Free Public Library.)

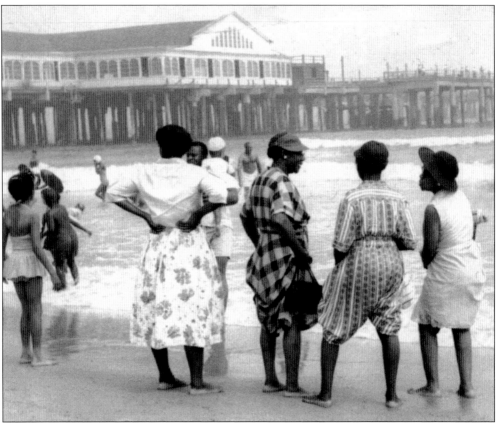

These ladies were not prepared to go in the water but still wanted to get their feet wet in the 1940s. (Photograph by John Mosley; courtesy of Charles L. Blockson Afro-American Collection, Temple University.)

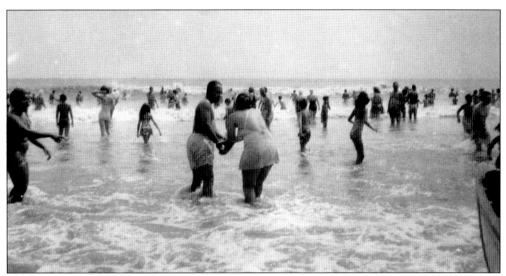

Folks traveled from afar, including this group from Washington, DC. Mary Belle Stanback (left), Tommy Stanback (middle), and Mary Etta Donfor (right) splash in the cooling waters at the Atlantic City Beach in 1952. (Photograph by Dr. Anthony Robert Donfor; courtesy of Charlene Donfor.)

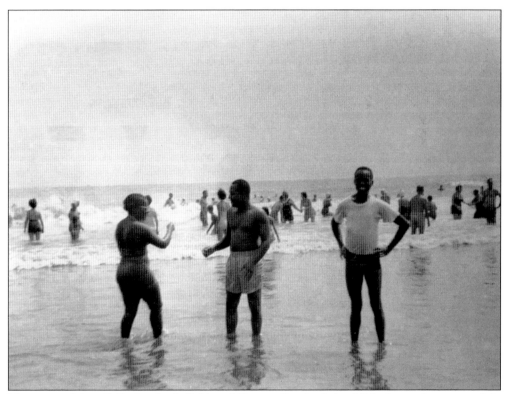

Vacationers Mary Belle Stanback (left) and Tommy Stanback (middle) play in the water, while Dr. Anthony Donfor Jr. (right) grins for the camera. (Photograph by Mary Etta Donfor; courtesy of Charlene Donfor.)

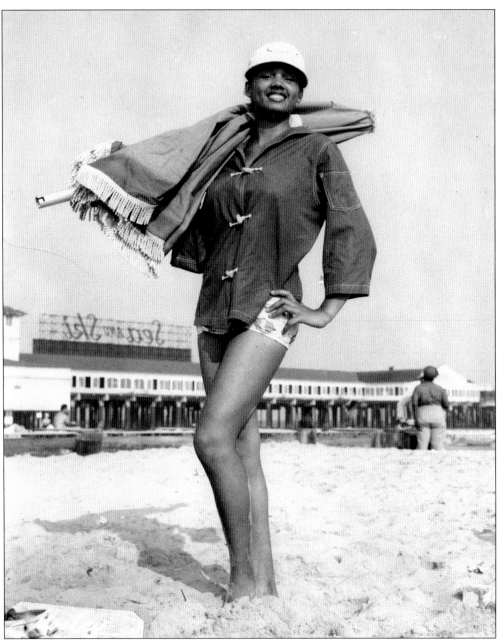

Carolyn Ayres of Moorestown, New Jersey, is carrying her umbrella and posing for photographer John W. Mosley (1907–1969), who documented African American life in Philadelphia and Atlantic City from the 1930s to the 1960s through images. Starting in 1934 when he moved to Philadelphia, he worked for the Barksdale Photography Studio. (Photograph by John Mosley; courtesy of Charles L. Blockson Afro-American Collection, Temple University.)

This woman, who is kneeling on a blanket with her children, is all smiles at the beach. (Photograph by John Mosley; courtesy of Charles L. Blockson Afro-American Collection, Temple University.)

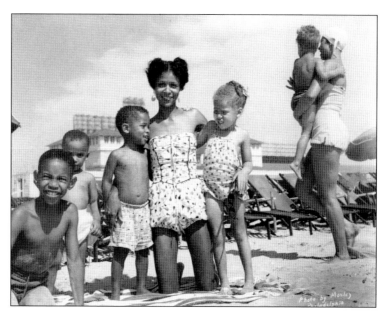

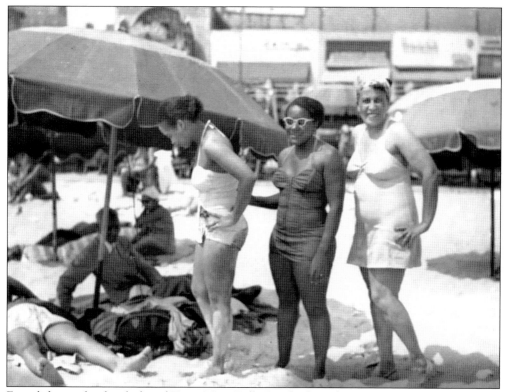

From left to right, family friend Kitty, Mary Belle Stanback, and Mary Etta Donfor have fun on the beach in 1952. (Photograph by Dr. Anthony Robert Donfor; courtesy of Charlene Donfor.)

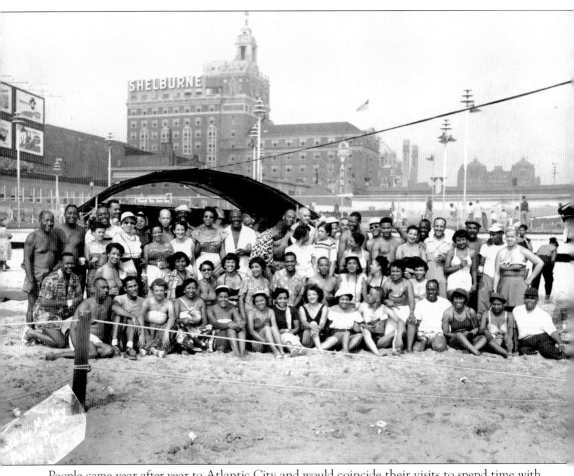

People came year after year to Atlantic City and would coincide their visits to spend time with the same friends and families. This group reunited on the beach in the early 1950s. (Photograph by John Mosley; courtesy of Charles L. Blockson Afro-American Collection, Temple University.)

Two

NORTHSIDE BUSINESSES AND NEIGHBORHOOD

Whether in the South or the North, African American communities were negatively impacted by the enforcement of racial segregation. In spite of this, the Northside of Atlantic City was a thriving community and neighborhood. The Atlantic City Board of Trade, which supported the efforts of Black entrepreneurs, publicized the establishments of doctors, lawyers, teachers, firemen, and policemen, as well as boardinghouses, restaurants, funeral homes, dentist offices, doctor offices, grocery stores, and, of course, Madame Sarah Spencer Washington's Apex beauty parlors and factories. Over 137 businesses were condensed within a mile radius of the neighborhood. Years after the erection of the Fitzgerald Auditorium, Black nightclubs such as Club Harlem, Grace's Little Belmont, and the Wonder Gardens on North Kentucky Avenue provided classy entertainment during summer evenings. Famous stars such as the Mills Brothers, Sammy Davis Jr., and Nat King Cole; comedians such as Slappy White, Jackie "Moms" Mabley, and Redd Foxx; and beautiful showgirls and dancers like Joan Meyers Brown, Lon Fontaine, and Joan Fontaine, who appeared with Larry Steele's *Smart Affairs*, staged performances for tourists and local residents on a weekly basis.

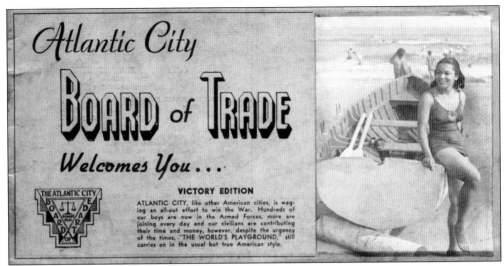

Similar to Victor Green's *The Negro Motorist Green-Book*, the Atlantic City Board of Trade published a directory of local businesses and organizations to accommodate visitors' needs. Even during World War II, the group continued to encourage tourists to visit "The World's Playground." (Courtesy of Atlantic City Heritage Collections, Atlantic City Free Public Library.)

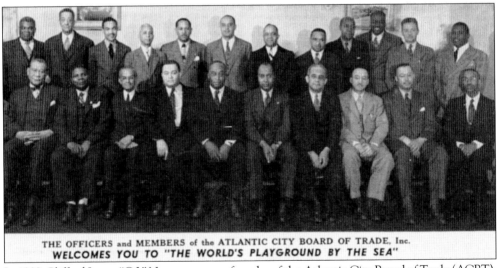

In 1929, Clifford James "C.J." Newsome was a founder of the Atlantic City Board of Trade (ACBT), which became the Black Chamber of Commerce, promoting Atlantic City as a place for African American conventions. He successfully brought African American businesses and conventions to the resort where dollars were spent in the Northside, far from Boardwalk hotels from which they were barred. The ACBT lost most of its influence with the advent of the civil rights movement as businesses along the beach opened up to diverse clientele. Though the board of trade's influence waned after desegregation, Newsome kept it running until his death in 1981, always seeking to attract more people to his hometown. This image shows the 1947 officers and members of the ACBT. (Courtesy of Atlantic City Heritage Collections, Atlantic City Free Public Library.)

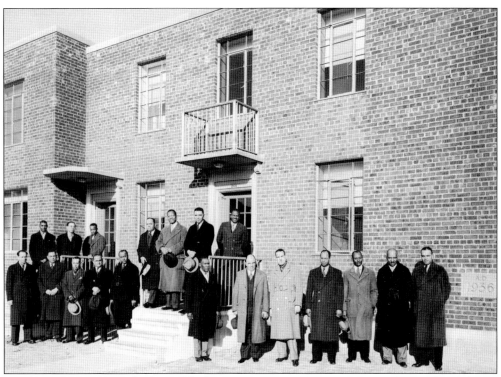

Stanley Holmes Village, the first public housing project in New Jersey, opened in 1936 in Atlantic City. Businessmen from the Northside tour the buildings at the opening. Shown here are, from left to right, (first row) J. Cruickshank (mechanic), C.M. Cain (housing manager), W. Buchner (restaurateur), W.A. Dert (lawyer), L.D. Wright (pharmacist), J.Y. Jones (shoe salesman), W.M. Snowden (hotel manager), S. Wyllie (bar and café owner), J.S. Bates (Bates Ice Cream), G.D. Hinman (auto service station), H. Hunt (salesman), and F. Johnson (hotel manager); (second row) F. Newton (grocer), C.G. Hamilton (salesman), L.E. McCall (bar and café owner), A.W. Rice (mechanic), A.B. Washington (dentist), L.P. Morris (dentist), and O.T. Davis (secretary, YMCA). (Courtesy of Atlantic City Heritage Collections, Atlantic City Free Public Library.)

After Stanley Holmes Village opened, families moved in, eager to start their lives in their own homes. Children, such as these two, played in the courtyard and were watched over by all the community members. (Courtesy of Atlantic City Heritage Collections, Atlantic City Free Public Library.)

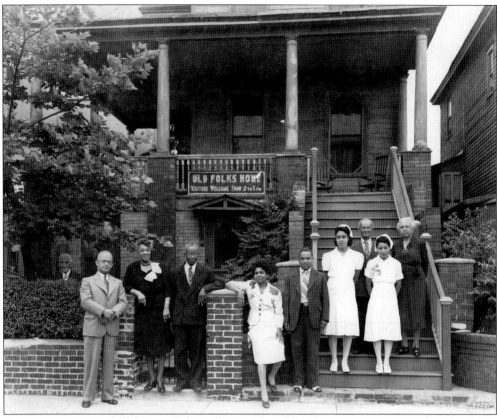

Segregation impacted all facets of life at all ages. The Old Folks Home at Hummock and Indiana Avenues welcomed elderly African Americans, as shown here in 1944. (Photograph by Fred Hess and Son; courtesy of Stockton University Richard E. Bjork Library Special Collections.)

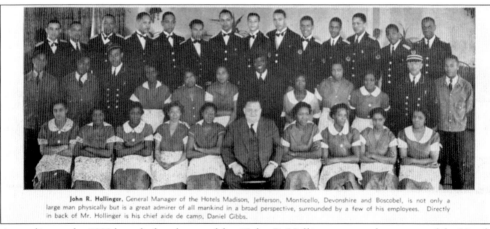

John R. Hollinger, General Manager of the Hotels Madison, Jefferson, Monticello, Devonshire and Boscobel, is not only a large man physically but is a great admirer of all mankind in a broad perspective, surrounded by a few of his employees. Directly in back of Mr. Hollinger is his chief aide de camp, Daniel Gibbs.

According to the 1939 board of trade pamphlet, "John R. Hollinger, general manager of the Hotels Madison, Jefferson, Monticello, Devonshire, and Boscobel, is not only a large man physically but is a great admirer of all mankind in a broad perspective, surrounded by a few of his employees. Directly behind Mr. Hollinger is his chief aide de camp, Daniel Gibbs." (Courtesy of Atlantic City Heritage Collections, Atlantic City Free Public Library.)

Another option for lodging was Attuck's Hotel at 1120 Drexel Avenue, which advertised good service for as little as $1 in 1939. (Courtesy of Atlantic City Heritage Collections, Atlantic City Free Public Library.)

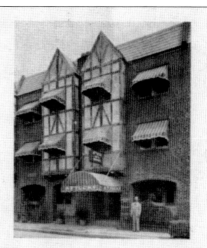

PHONE 5-9298 OPEN ALL YEAR

RATES -- $1.00 UP

FOR GOOD SERVICE TRY

THE ATTUCK'S HOTEL

1120 DREXEL AVENUE

C. A. AERIE, Prop.

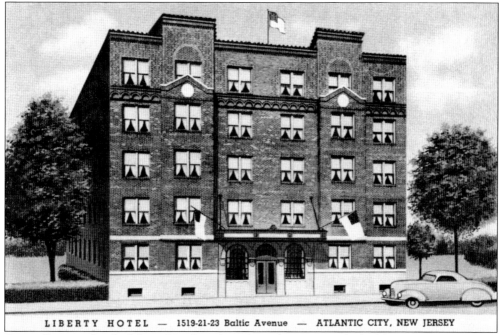

LIBERTY HOTEL — 1519-21-23 Baltic Avenue — ATLANTIC CITY, NEW JERSEY

Originally opened as the Liberty Hotel at 1519–1523 Baltic Avenue, the building is currently Liberty Apartments. (Courtesy of Atlantic City Heritage Collections, Atlantic City Free Public Library.)

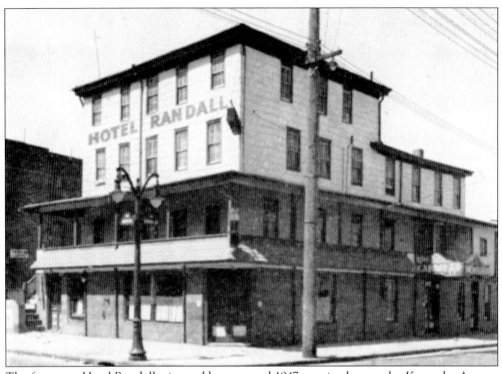

The four-story Hotel Randall, pictured here around 1947, was in the popular Kentucky Avenue entertainment district and hosted a cabaret on the ground floor. (Courtesy of Atlantic City Heritage Collections, Atlantic City Free Public Library.)

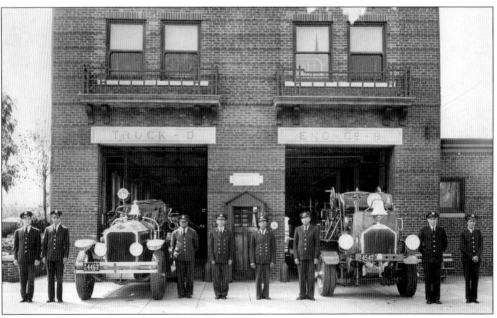

Atlantic City Fire Department Company 9, shown here in 1949, was comprised of Black firefighters. (Courtesy of Stockton University Richard E. Bjork Library Special Collections.)

Here, the public safety director swears in a firefighter in the early 1950s while the powerful state senator Frank S. "Hap" Farley looks on (center). (Courtesy of Stockton University Richard E. Bjork Library Special Collections.)

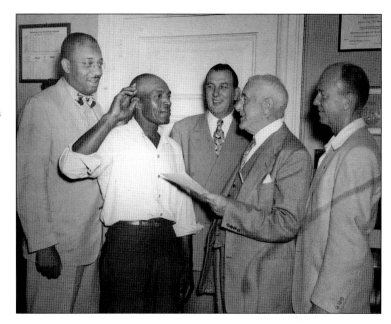

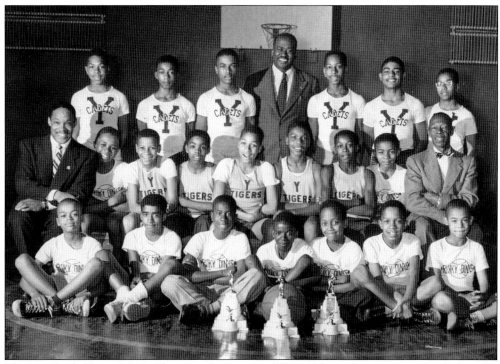

The Northside Young Men's Christian Association (YMCA) hosted sports teams, including the youth shown here who were part of the Rinky Dinks, Tigers, and Cadets. (Courtesy of Stockton University Richard E. Bjork Library Special Collections.)

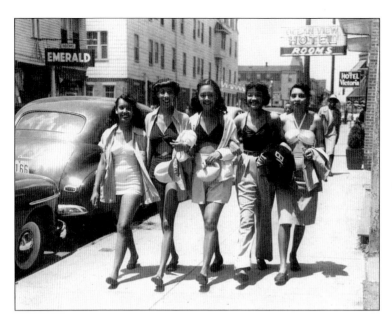

The Northside neighborhood was located only a few blocks from the beach. Here are five women walking down the street on their way to the beach. (Courtesy of Charles L. Blockson Afro-American Collection, Temple University.)

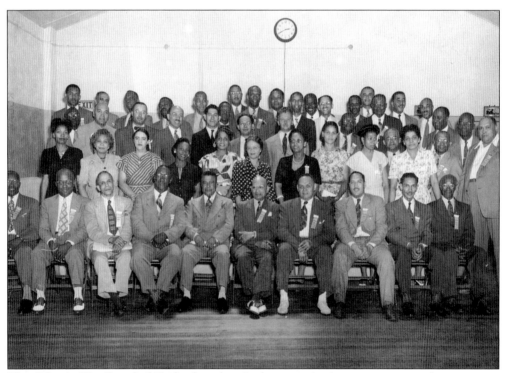

The Atlantic City Board of Trade also advertised to organizations to encourage them to come for conferences and conventions, such as this group that met in the early 1950s. (Courtesy of Stockton University Richard E. Bjork Library Special Collections.)

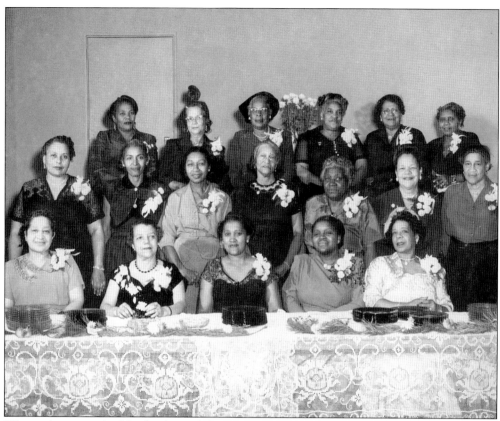

Women living in the Northside in Atlantic City organized and met for a variety of reasons, including the social aspect and various causes. (Courtesy of Stockton University Richard E. Bjork Library Special Collections.)

Kenneth B. Hawkins Post 61 of the Veterans of Foreign Wars (VFW) participated in local events and parades. (Courtesy of Stockton University Richard E. Bjork Library Special Collections.)

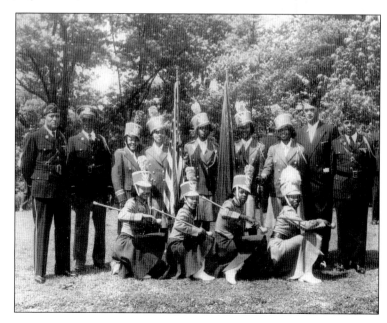

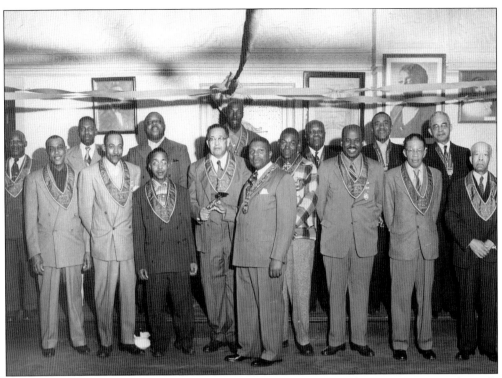

C.J. Newsome received the gavel to signify his leadership in the Elks organization in the early 1950s. (Photograph by Fred Hess and Son; courtesy of Richard E. Bjork Library Special Collections, Stockton University.)

Across the street from Club Harlem was Grace's Little Belmont at 37 North Kentucky Avenue. It was owned by Hernan Daniels and his wife, Grace, from the mid-1930s through the 1970s. (Courtesy of Atlantic City Heritage Collections, Atlantic City Free Public Library.)

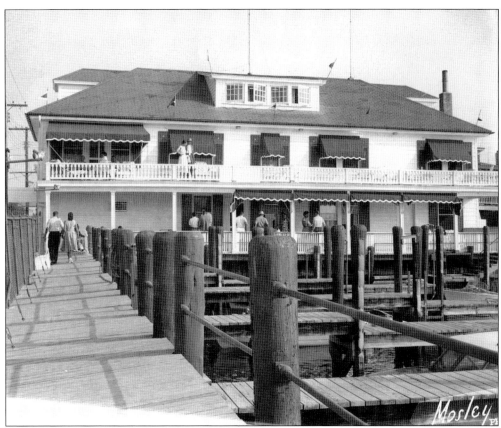

Located at 800 North Massachusetts Avenue, the Golden Key Yacht Club opened in the 1950s in the Atlantic City Inlet area. (Photograph by John Mosley; courtesy of Charles L. Blockson Afro-American Collection, Temple University.)

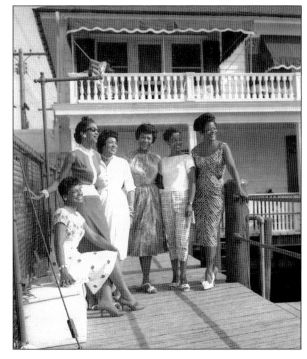

Ready for an afternoon on the water, Lola Wylie (far left) and Edythe Collins Greene (second from right) were at the Golden Key Yacht Club with a few of their friends. (Photograph by John Mosley; courtesy of Charles L. Blockson Afro-American Collection, Temple University.)

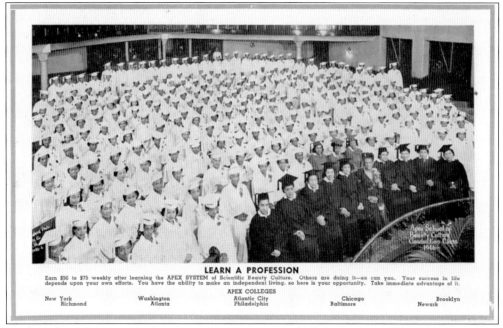

LEARN A PROFESSION

Earn $50 to $75 weekly after learning the APEX SYSTEM of Scientific Beauty Culture. Others are doing it—so can you. Your success in life depends upon your own efforts. You have the ability to make an independent living, so here is your opportunity. Take immediate advantage of it.

APEX COLLEGES

| New York Richmond | Washington Atlanta | Atlantic City Philadelphia | Chicago Baltimore | Brooklyn Newark |

Madame Sara Spencer Washington's Apex empire included a beauty college at 1705 Arctic Avenue. Later, her colleges included locations across the globe. By 1946, the Apex School of Beauty Culture had expanded to 10 locations. Here, the graduating class of 1946 prepares to start their careers in the hair-care industry. (Courtesy of Atlantic City Heritage Collections, Atlantic City Free Public Library.)

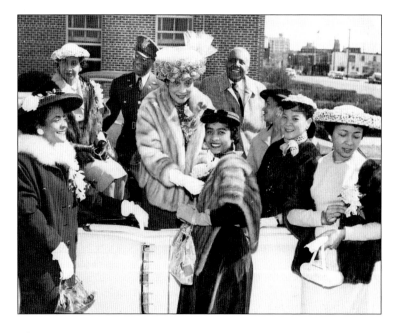

Madame Washington sponsored the Arctic Avenue Easter Parade, beginning in the 1940s, in response to discrimination against Black participants in the annual Atlantic City Boardwalk Easter Parade. Here, Washington is shown at center, standing in the car. (Courtesy of Atlantic City Heritage Collections, Atlantic City Free Public Library.)

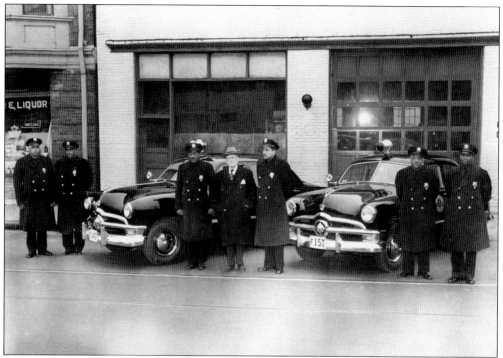

The city employed Black officers to patrol the Northside neighborhood. Positive interactions between Black police officers and community members were frequent. This group from 1950 includes officer Ben Anderson (fifth from right). (Photograph by Fred Hess and Son; courtesy of Richard E. Bjork Library Special Collections, Stockton University.)

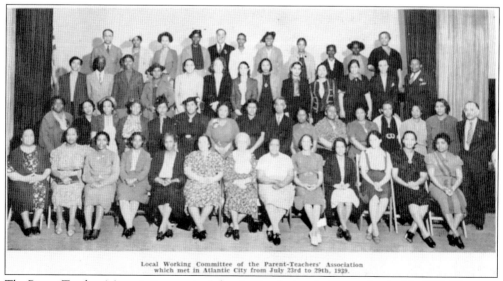

Local Working Committee of the Parent-Teachers' Association which met in Atlantic City from July 23rd to 29th, 1939.

The Parent-Teachers' Association met in Atlantic City during the Depression in July 1939. (Courtesy of Atlantic City Heritage Collections, Atlantic City Free Public Library.)

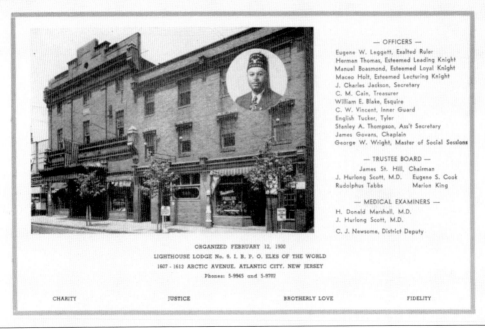

The Northside neighborhood Elks Lodge, founded in 1900, met on Arctic Avenue in 1947. (Courtesy of Atlantic City Heritage Collections, Atlantic City Free Public Library.)

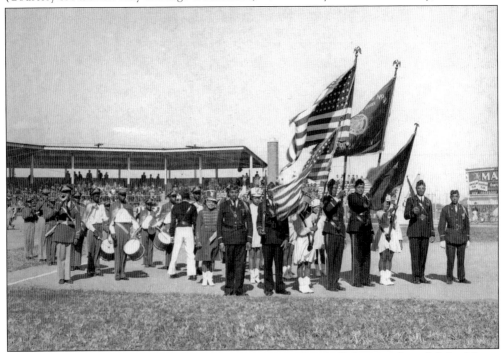

A stadium in the Northside was named for Negro League baseball player and coach John Henry "Pop" Lloyd in October 1949. Shown here at the opening festivities is the color guard from Kenneth B. Hawkins VFW Post 61. (Courtesy of Stockton University Richard E. Bjork Library Special Collections.)

Pop Lloyd (second row, far left) coached the Farley All Stars, a semiprofessional Black baseball team in Atlantic City. Sen. Frank "Hap" Farley was the team's patron. (Courtesy of Stockton University Richard E. Bjork Library Special Collections.)

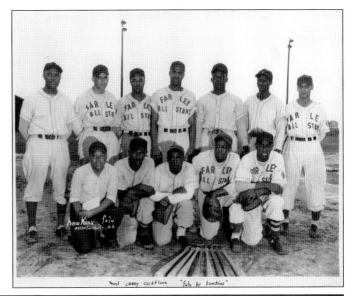

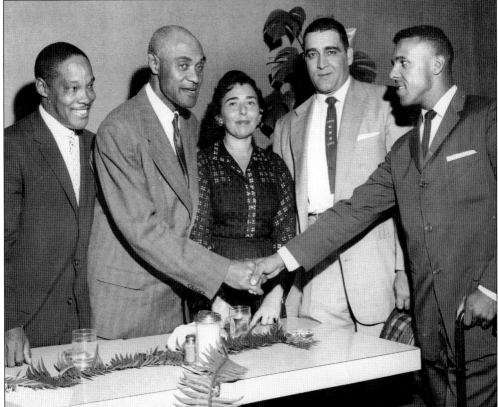

The Atlantic City sports community hosted many events. From left to right, Ralph Greene, baseball legend Pop Lloyd, Adele Polk, Ben Anderson, and the first African American professional ice hockey player Arthur Dorrington attended this banquet on September 9, 1958, for the Westside Little League. (Photograph by John Mosley; courtesy of Charles L. Blockson Afro-American Collection, Temple University.)

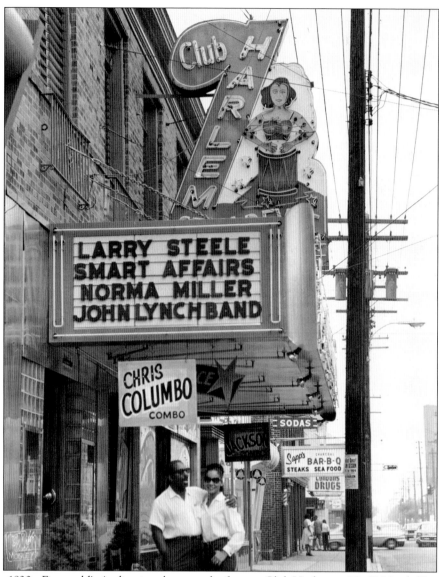

In the 1930s, Fitzgerald's Auditorium became the famous Club Harlem at 30–32 North Kentucky Avenue. Thousands of performers graced the stage there over the decades. Here, the club is shown in 1952, with the marquee announcing Larry Steele's *Smart Affairs*, Norma Miller, and the John Lynch Band. Below is a small banner promoting the Chris Columbo Combo. Columbo was a drummer who led the Club Harlem house band. Kentucky Avenue was a busy hub for life on Atlantic City's Northside, with restaurants and businesses like Sapp's Bar-B-Q, London's Drug Store, barbershops, boardinghouses, and hotels serving the Black clientele. Sapp's Bar-B-Q and London's Drugstore were located on KY and the Curb, a nickname for where Kentucky Avenue and Arctic Avenue met. In this image, automobiles parked and driven down Kentucky Avenue are shown. By now, one may have noticed that street names in Atlantic City resemble place names on the Monopoly board game that the Parker Brothers produced in 1935, when Atlantic City was recognized as "one of the most luxurious and famous resorts in America." (Photograph by John Mosley; courtesy of Charles L. Blockson Afro-American Collection, Temple University.)

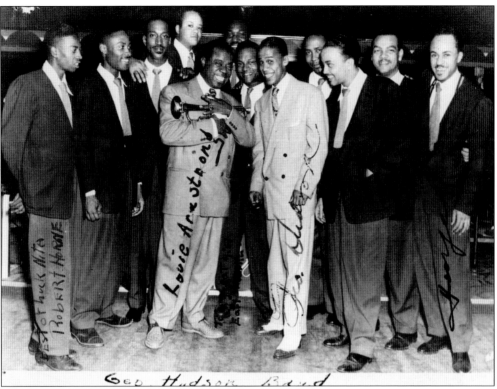

The George Hudson band, which consisted of Hudson (center right), an American trumpeter and bandleader, performed at Club Harlem with Louis Armstrong (center left) around 1950. Hudson was born in 1910 and died on July 10, 1996. (Courtesy of Atlantic City Heritage Collections, Atlantic City Free Public Library.)

Another "Year" — Another "Great" Show

THE INIMITABLE

BEN ALTEN'S AND CLIFF WILLIAMS'

CLUB HARLEM

32 N. Kentucky Avenue Atlantic City, N. J.

PROUDLY ANNOUNCES

ITS

Grand Opening !

Thursday Evening, June 23, 1960

When It Will Present In Response

To Overwhelming Demand

•

THE

NEWEST EDITION OF

Club Harlem opened for the season when the summer tourists began to return. Pictured is the 1960 flier for the grand opening. (Courtesy of Ronald J. Stephens.)

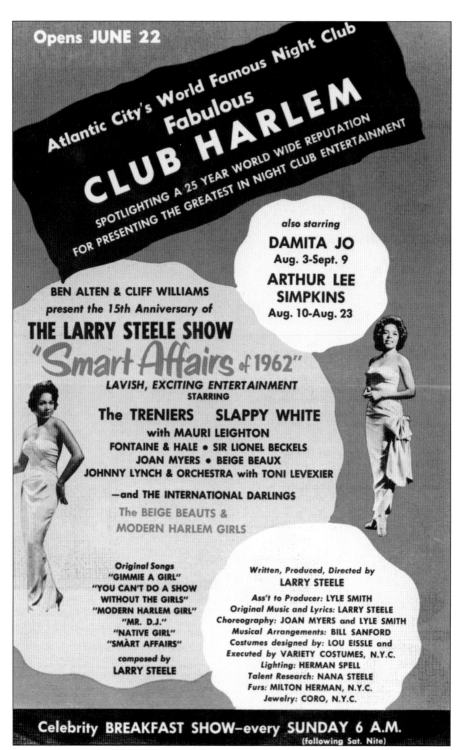

The 25th anniversary of Club Harlem in 1962 highlighted performances by Damita Jo, Arthur Lee Simpkins, and comedian Slappy White. Larry Steele brought his variety show, *Smart Affairs*, year after year to the club. (Courtesy of Ronald J. Stephens.)

From left to right, Ricky Ford, Sammy Davis Jr., Owissa Robinson, Larry Steele, and Betty Jo Alvies are in the dressing room at Club Harlem in July 1964. (Courtesy of Betty Jo Alvies.)

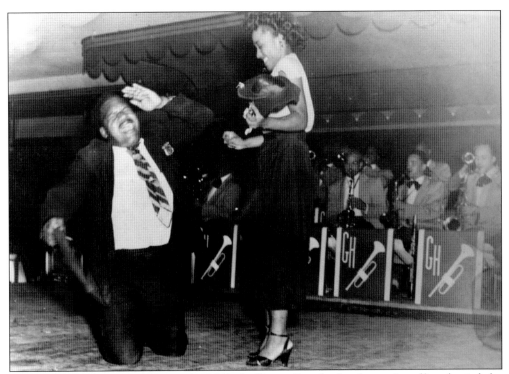

During the final act in 1950, Rosebud "Shake Dancer" and a local security officer buried the show (meaning the audience is seeing the finale of the show or the season). The Shake was a popular dance fad of the 1960s with characteristics of jerkiness of limbs, head shaking, and no particular dance moves or steps. (Photograph by Alma Fay Horn; courtesy of Atlantic City Heritage Collections, Atlantic City Free Public Library.)

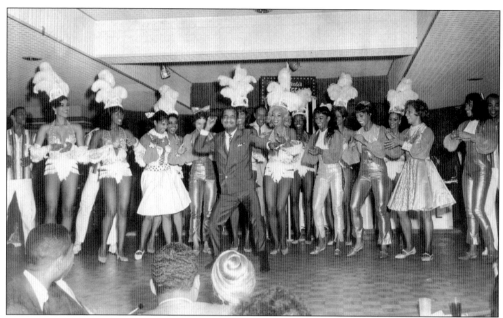

Sammy Davis Jr. and the cast, featuring showgirls, dancers, and Larry Steele standing in the background, are pictured on stage at Club Harlem during the summer of 1963. Sammy Davis Jr. discovered entertainer Lola Falana, who was working as a Club Harlem chorus line member, and he extended invitations to other Rat Pack members, such as Frank Sinatra and Dean Martin, to see the shows. (Courtesy of Betty Jo Alvies.)

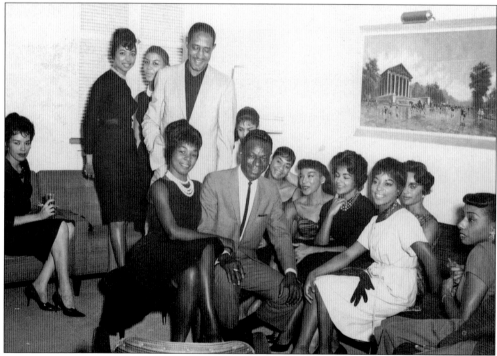

Nat King Cole (center, seated) poses with Larry Steele and his *Smart Affairs* revue. (Courtesy of Betty Jo Alvies.)

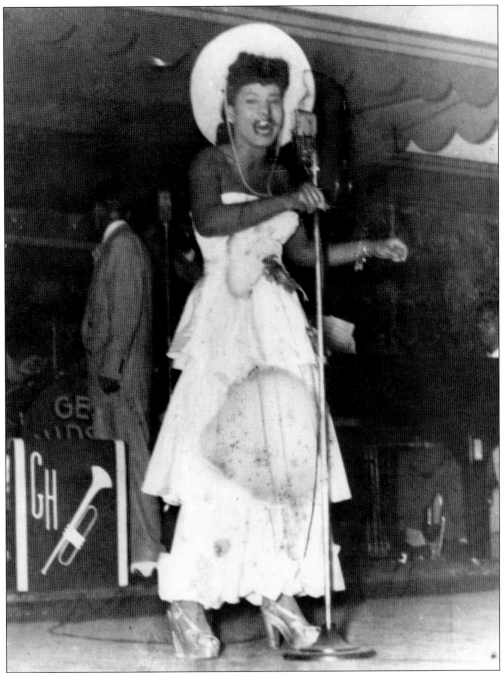

This singer performs "Cow Cow Boogie" at Club Harlem in the 1950s. "Cow Cow Boogie" was a "country-boogie"–style blues song, with lyrics by Benny Carter and Gene De Paul and music by Don Raye. The original song was written for the 1942 Abbot and Costello film *Ride 'em Cowboy*; Ella Fitzgerald was a member of the cast. The song relied on the folklore of a singing American West cowboy from the city who communicates a message to his "motherless calves" to "get hip." (Photograph by Alma Fay Horn; courtesy of Atlantic City Heritage Collections, Atlantic City Free Public Library.)

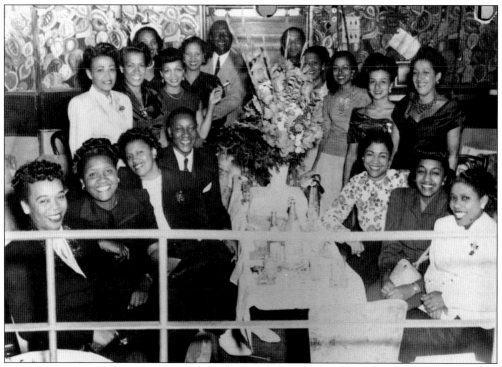

The various Kentucky Avenue clubs were always packed with people having a good time. (Photograph by Alma Fay Horn; courtesy of Atlantic City Heritage Collections, Atlantic City Free Public Library.)

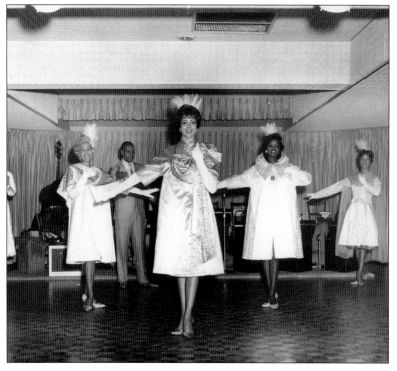

Betty Jo Alvies (left), Ricky Ford (front center), Vanzetta McCoy (third from left), and Bonnie Lynch (far right) with Larry Steele (left) in the background are at Club Harlem around 1963. (Courtesy of Betty Jo Alvies.)

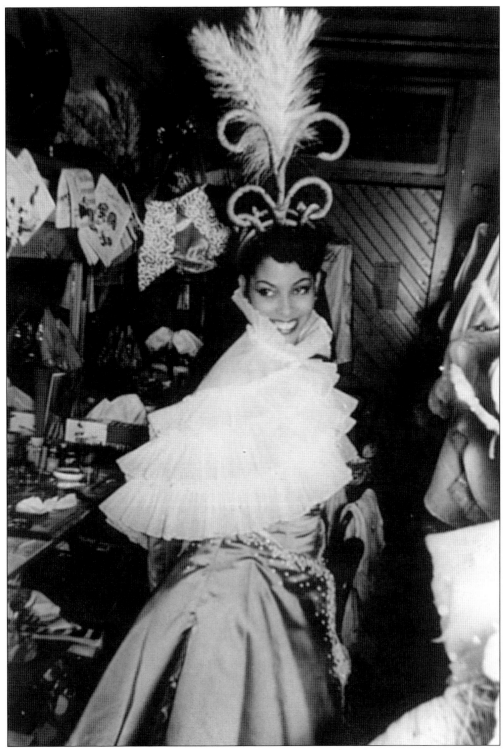

After a busy weekend of performances at Club Harlem, *Smart Affairs* dancer Joan Fontaine poses for the camera backstage in the dressing room in August 1956. (Courtesy of Joan Fontaine.)

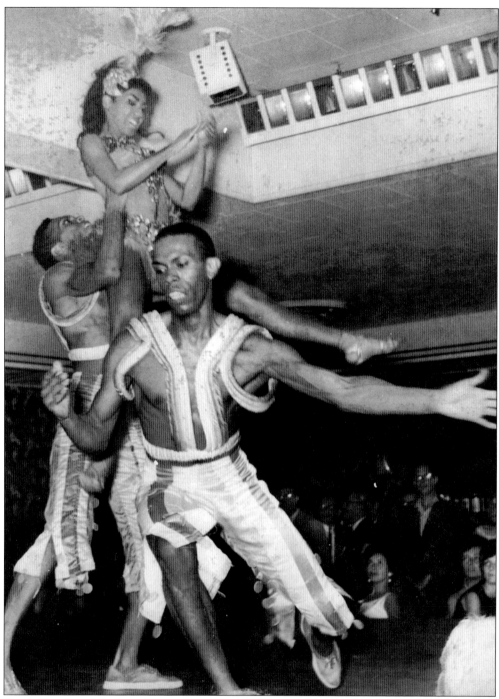

Frank Hatchett lifts Joan Meyers Brown as Gilbert Andre Pitts leans forward in this 1959 photograph. (Courtesy of Joan Meyers Brown.)

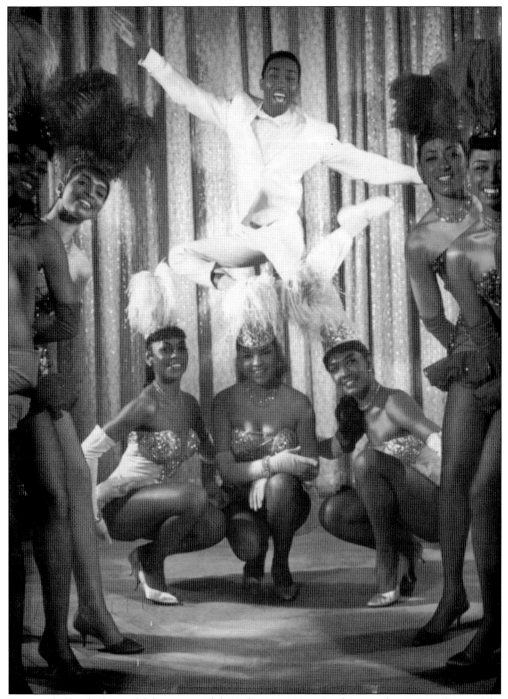

Surrounded by the beautiful dancers at Club Harlem, Lon Fontaine leaps in the air. Kneeling at right is Joan Meyers Brown. Brown later founded the Philadelphia Dance Company, PHILADANCO, and the Philadelphia School of Dance Arts. (Courtesy of Joan Meyers Brown.)

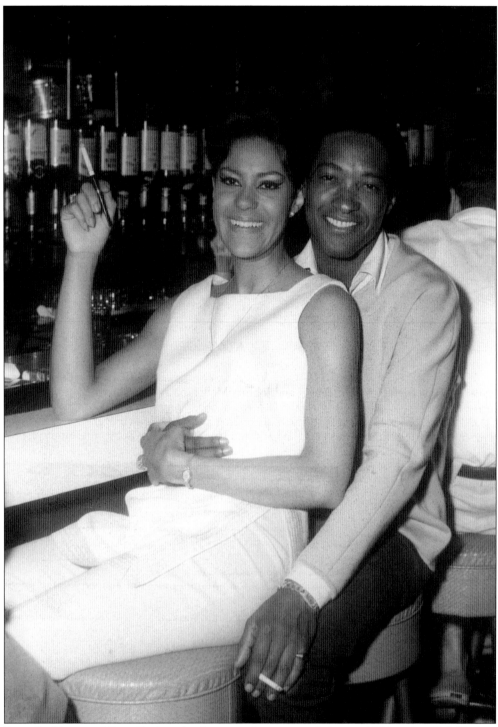

Betty Jo Alvies and Sam Cooke relax between shows around August 1964 at the Club Harlem bar. Betty Jo was not drinking because she was performing. (Courtesy of Betty Jo Alvies.)

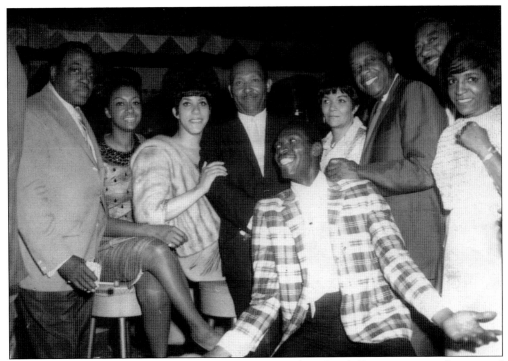

After one nightly performance at the Basin Street South in South Boston, a major fire erupted and ended shows at the club and the tour of the *Arthur Braggs Idlewild Revue*. Three nights later gave longtime friends Arthur Braggs and Johnny McIlvaine an opportunity to rent a private plane and pilot to take them to Atlantic City to see one of Larry Steele *Smart Affairs* shows at Club Harlem. From left to right in this 1964 photograph are Arthur Braggs, Carlean Gill, an unidentified couple, Bonita McIlvaine, and husband Johnny McIlvaine Sr., an unidentified couple, and an unidentified man kneeling center front. (Courtesy of Bonnie McIlvaine.)

Larry Steel produced classy shows for 30 consecutive seasons at Club Harlem. His revue was an institution, and his group participated in the Miss America Pageant in the early 1960s. (Courtesy of Joan Meyers Brown.)

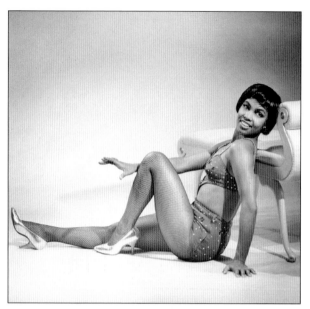

Pattie L. Harris-Young enjoyed performing at Club Harlem and working for owner Leroy "Pops" Williams, who was a close friend. Pattie's real passion, however, was sharing her love of jazz and tap dance through performance instruction. She opened her first dance school in Atlantic City in the early 1960s, and taught dance classes at Atlantic City Community College and Stockton University as well as at Glassboro State College as an adjunct instructor. Pattie was multitalented: a choreographer, costume designer, dance instructor, playwright, and vocalist. (Courtesy of the African American Heritage Museum of Southern New Jersey Inc.)

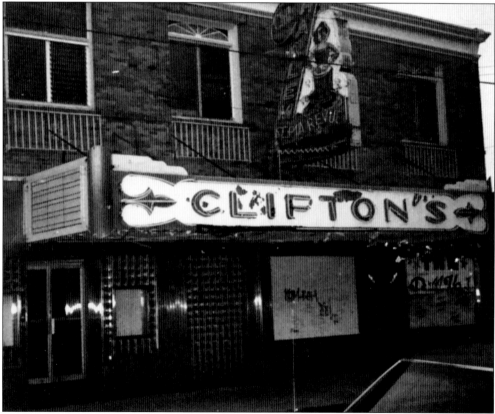

The coming of the casinos spelled the end of the Kentucky Avenue nightclub scene. One by one, the clubs shuttered, and the entertainers moved to the bigger casino venues. Club Harlem closed in the 1980s and was later demolished. (Courtesy of Atlantic City Heritage Collections, Atlantic City Free Public Library.)

Three

ATLANTIC CITY IN THE CIVIL RIGHTS MOVEMENT

African Americans from Atlantic City, Philadelphia, Delaware, and Washington, DC, continued to brave Jim Crow conditions to enjoy the beach. Families traveled by automobile, rail, or bus with foods that would last the entire day since they were not afforded opportunities to make purchases from restaurants. Many packed cold-cut sandwiches and chicken because it could last all day.

During the same year the Civil Rights Act of 1964 went into effect, the Democratic National Convention was held in Atlantic City. Thousands of civil rights volunteers and leaders visited the city to attend the convention, including the Reverend Dr. Martin Luther King Jr. and Fannie Lou Hamer. Celebrities such as former world heavyweight boxing champion Joe Louis and entertainers Sammy Davis Jr. and Sarah Vaughn toured the beach before and during the convention. Sammy Davis Jr. was a frequent beachgoer.

By the time the civil rights bill was signed into legislation, the all-Black beach disappeared. Atlantic City beach areas were open to everyone. By the late 1970s, the casino establishments had reinvented the culture of the beach and the Boardwalk by transforming the scene into a world-class gambling resort. This, in turn, changed the atmosphere on the Atlantic City beaches, and the family feeling of Chicken Bone Beach diminished.

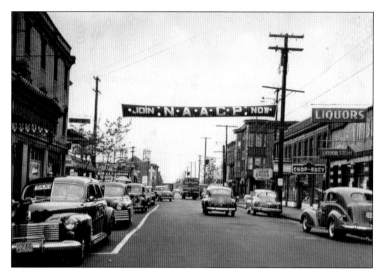

The local chapter of the National Association for the Advancement of Colored People (NAACP) hung a large banner for members in Atlantic City's Northside neighborhood over Arctic Avenue around the 1940s. (Courtesy of Atlantic City Heritage Collections, Atlantic City Free Public Library.)

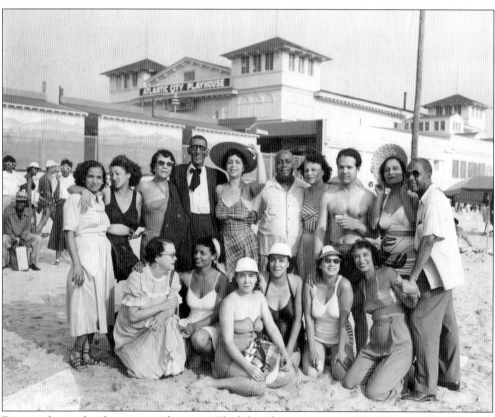

Even as the civil rights era was dawning, Black beachgoers continued to frequent their favorite spot. Here, friends pose in front of an Atlantic City pier. (Photograph by John Mosley; courtesy of Charles L. Blockson Afro-American Collection, Temple University.)

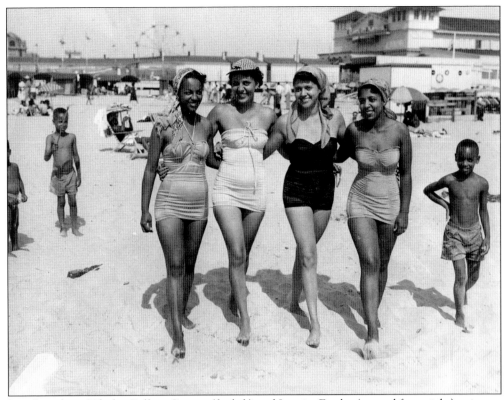

Local residents Edythe Collins Greene (far left) and Juanita Fowler (second from right) enjoy an afternoon at the beach along with friends. (Photograph by John Mosley; courtesy of Charles L. Blockson Afro-American Collection, Temple University.)

Mary Lou Sullivan strikes a pose while sunbathing on the sand. (Photograph by John Mosley; courtesy of Charles L. Blockson Afro-American Collection, Temple University.)

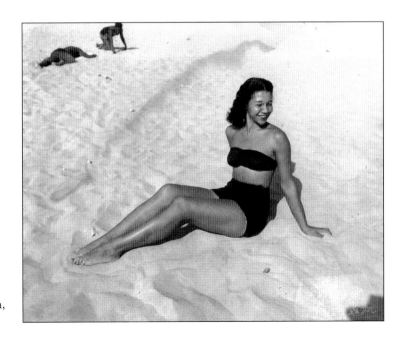

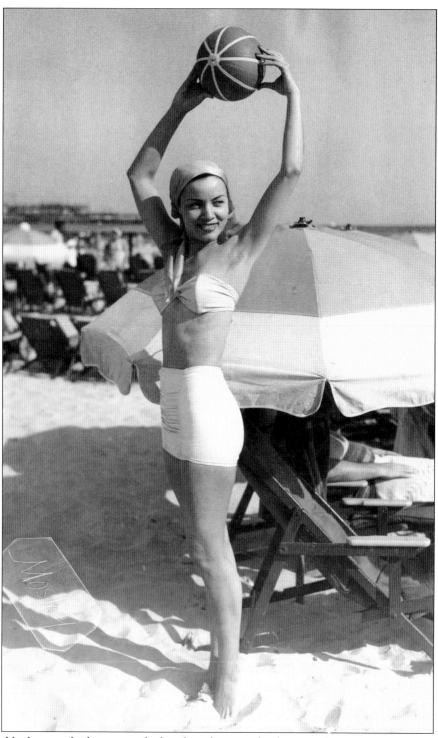

A good-looking sunbather enjoys the beach as she poses for the camera with a beach ball hanging over her head in this c. 1947 image. (Photograph by John Mosley; courtesy of Charles L. Blockson Afro-American Collection, Temple University.)

Cotton Club star and wife of middleweight boxing champion Sugar Ray Robinson, Edna Mae Robinson relaxes on the beach while reading a 1941 issue of *Pictorial Album*. (Photograph by John Mosley; courtesy of Charles L. Blockson Afro-American Collection, Temple University.)

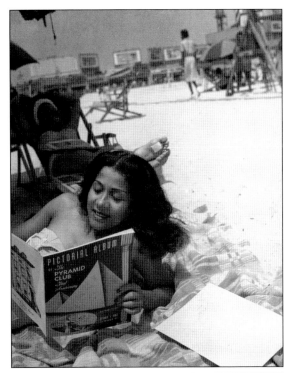

By 1960, boat excursions and other tourist attractions were integrated into Atlantic City. Anthony Robert Donfor takes a ride with others on the popular Starn's Restaurant boat. (Courtesy of Charlene Donfor.)

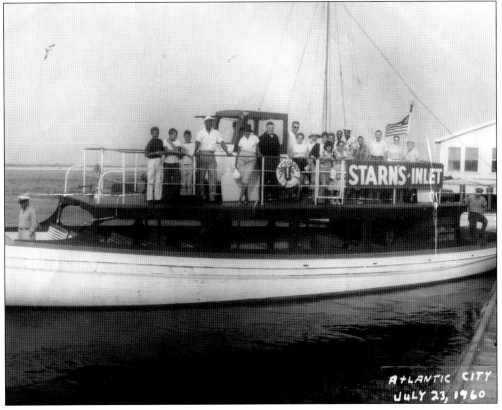

Ralph Greene of Atlantic City docks a boat at the Golden Key Yacht Club. (Photograph by John Mosley; courtesy of Charles L. Blockson Afro-American Collection, Temple University.)

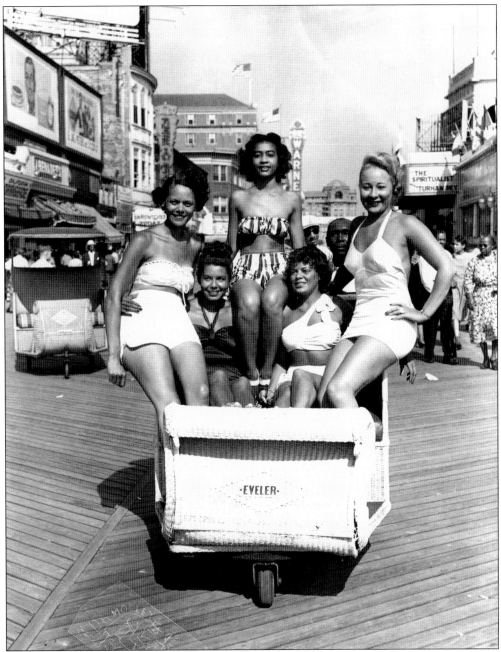

Beginning in the late 1950s, norms began to relax somewhat, and it was more common to see people in swimsuits on the Boardwalk, such as these ladies enjoying a ride in a rolling chair. (Photograph by John Mosley; courtesy of Charles L. Blockson Afro-American Collection, Temple University.)

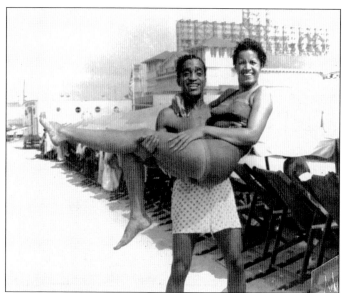

Entertainer Sammy Davis Jr., who was one of the 500 Club and Club Harlem favorites, holds a woman in his arms on Chicken Bone Beach in August 1954. The appearances of prominent figures such as Sammy Davis Jr., boxing champions Joe Louis and Sugar Ray Robinson, and singers Sarah Vaughn, added to Chicken Bone Beach's growing mystique and uniqueness. (Photograph by John Mosley; courtesy of Charles L. Blockson Afro-American Collection, Temple University.)

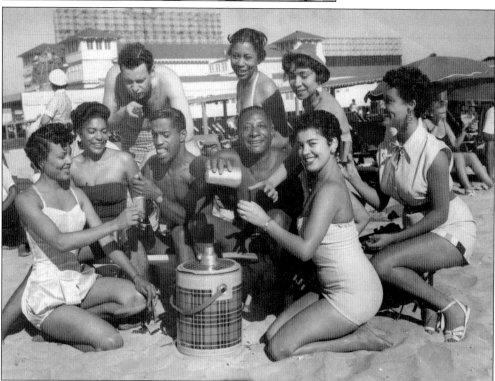

Another day, another party on the beach with Sammy Davis Jr. (left of center), who is surrounded by beautiful women and two other men enjoying each other's company in the sand. Davis is pictured cracking open a bottle of champagne while others hold out their glasses for a drink. Despite the glitz of famous entertainers, showgirls, and dancers and the appearances of celebrities, Chicken Bone Beach remained a family-centered beach that served the needs of working families of Atlantic City's Northside community. (Photograph by John Mosley; courtesy of Charles L. Blockson Afro-American Collection, Temple University.)

Former world heavyweight boxing champion Joe Louis sits with friends as fans stand near him on Chicken Bone Beach in this c. 1952 image. (Photograph by John Mosley; courtesy of Charles L. Blockson Afro-American Collection, Temple University.)

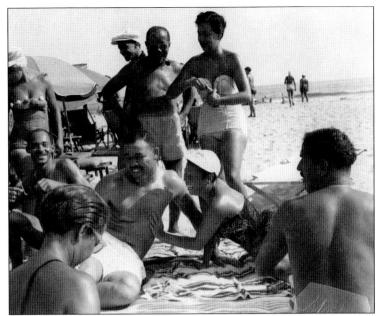

Madame Sara Spencer Washington (second row, second from right), a local entrepreneur and activist, enjoys the beach with a group in this c. 1940s photograph. (Photograph by John Mosley; courtesy of Charles L. Blockson Afro-American Collection, Temple University.)

The parking lot at Apex Golf Course in nearby Pomona, New Jersey, which was owned by Madame Washington, was full for a tournament in the early 1950s. (Photograph by Hawkins' Photo; courtesy of Atlantic City Heritage Collections, Atlantic City Free Public Library.)

The clubhouse at Apex Golf Course was located near Atlantic City. Madame Washington reportedly bought the golf course in the late 1940s after being turned away from a "Whites-only" establishment. She welcomed people from all races, ethnicities, and genders to the course. (Photograph by Hawkins' Photo; courtesy of Atlantic City Heritage Collections, Atlantic City Free Public Library.)

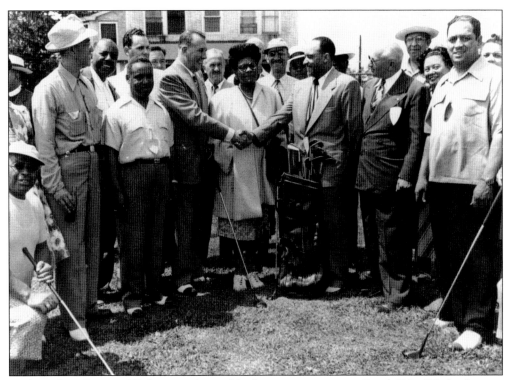

Madame Sara Spencer Washington (center) looks on as state senator Frank "Hap" Farley (center, left) shakes hands with another man at her golf course during a tournament in the 1950s. (Photograph by Hawkins' Photo; courtesy of Atlantic City Heritage Collections, Atlantic City Free Public Library.)

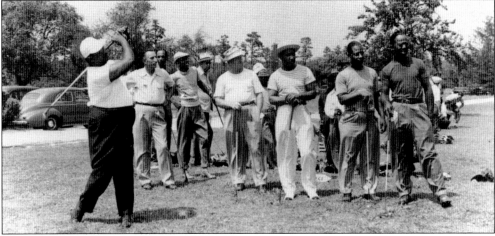

A group of men golfers tee off at the Apex Golf Course in this 1950s image. African Americans and golf share a rich history. Beginning in 1899, Dr. George F. Grant of Boston invented the wooden golf tee and had the good sense to apply for a patent on it. Although Grant never marketed his invention and never earned a dime from his intellect, African Americans of the Atlantic City Northside neighborhood understood Grant's contribution and honored it annually. The basic model of his invention is still used today. (Photograph by Hawkins' Photo; courtesy of Atlantic City Heritage Collections, Atlantic City Free Public Library.)

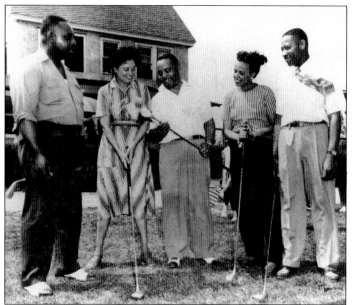

At the Apex Golf Course in the 1950s, a group of men and women golfers are having a discussion as they observe one man's golf club. Black golfers played the game very well after the American Civil War. Black history in golf is remembered and practiced in the 20th and 21st centuries through the skills of Tiger Woods, who holds the honor of today's main man of golf worldwide. (Photograph by Hawkins' Photo; courtesy of Atlantic City Heritage Collections, Atlantic City Free Public Library.)

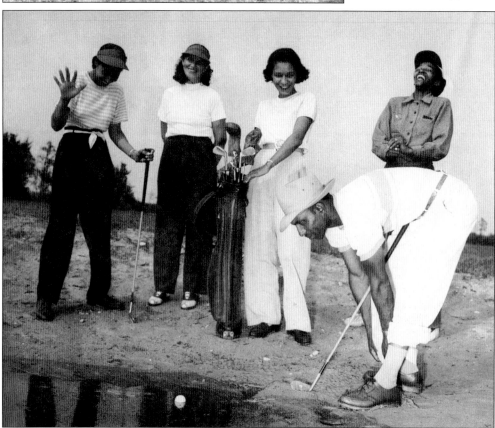

Looks like this golfer will have to take the penalty for the water hazard at the Apex Golf Course, but his companions sure are enjoying his distress. (Photograph by Hawkins' Photo; courtesy of Atlantic City Heritage Collections, Atlantic City Free Public Library.)

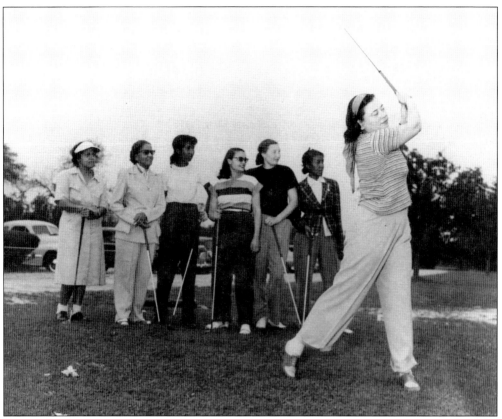

Marion Jordan Moore is one of the golfers taking a swing during a tournament at Pomona Golf Course in the 1950s. (Photograph by Hawkins' Photo; courtesy of Atlantic City Heritage Collections, Atlantic City Free Public Library.)

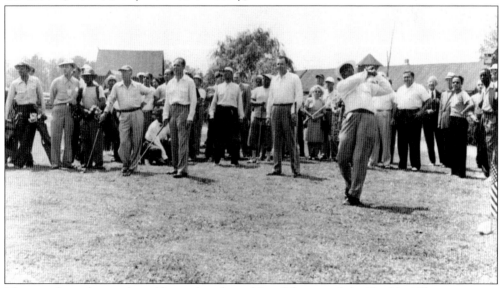

The crowd watches as the golfers make a long drive. (Photograph by Hawkins' Photo; courtesy of Atlantic City Heritage Collections, Atlantic City Free Public Library.)

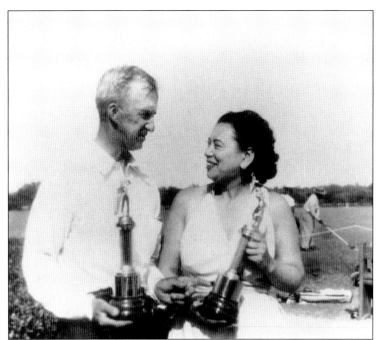

Two of the 1950s tournament winners at Madame Washington's Apex Golf Course pose with their trophies. (Photograph by Hawkins' Photo; courtesy of Atlantic City Heritage Collections, Atlantic City Free Public Library.)

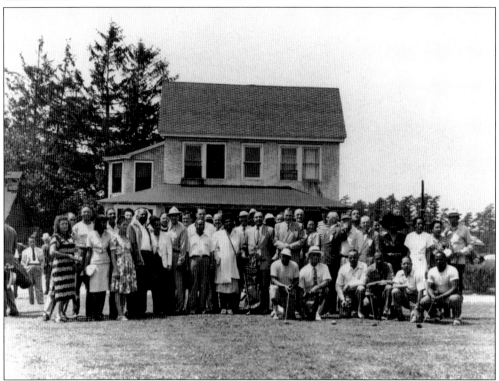

A crowd poses for a group photograph in front of the clubhouse at a 1950s golf tournament at Apex Golf Course. Madame Washington is pictured in the white jacket beside the man with the golf bag. (Photograph by Hawkins' Photo; courtesy of Atlantic City Heritage Collections, Atlantic City Free Public Library.)

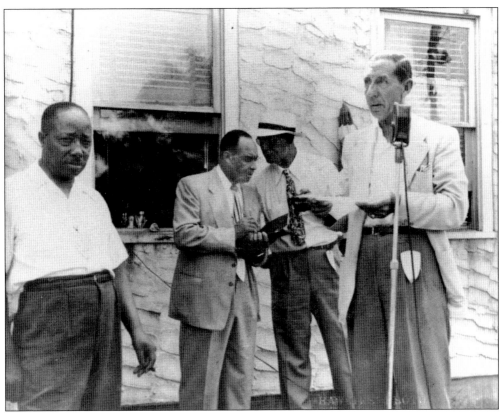

While the announcer gives tournament updates, several of the officials confer at Apex Golf Course. (Photograph by Hawkins' Photo; courtesy of Atlantic City Heritage Collections, Atlantic City Free Public Library.)

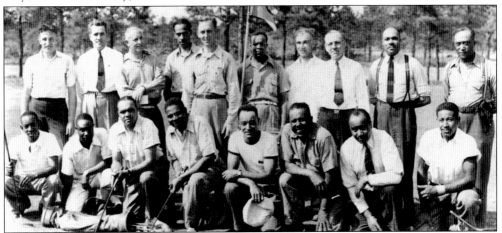

A group of black and white male golfers pose at the Apex Golf Course in this c. 1950s image. The United Golfers Association consisted of a group of African American professional golfers who operated a separate series of professional golf tournaments for Blacks during Jim Crow segregation. The organization was founded in 1925 by George Adams and continued in 1926 by Robert Hawkins, a golfer from Massachusetts. (Photograph by Hawkins' Photo; courtesy of Atlantic City Heritage Collections, Atlantic City Free Public Library.)

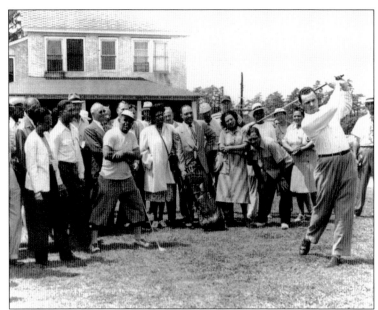

The crowd looks on with excitement as a golfer tees off during one of the annual tournaments at the golf course. Here, supporters cheer on and appreciate a good swing shot. (Photograph by Hawkins' Photo; courtesy of Atlantic City Heritage Collections, Atlantic City Free Public Library.)

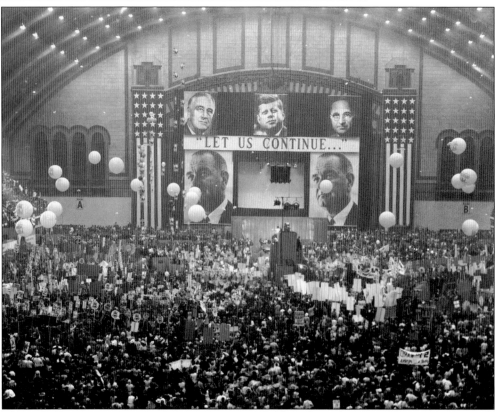

The 1964 Democratic National Convention was held in the Atlantic City Convention Hall, only steps away from Chicken Bone Beach. The Mississippi Democratic Freedom Party delegates, including Fannie Lou Hamer, were present but were not seated at the convention. (Courtesy of Atlantic City Heritage Collections, Atlantic City Free Public Library.)

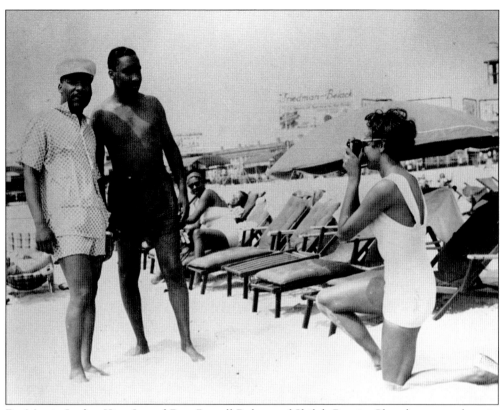

Dr. Martin Luther King Jr. and Rev. Russell Roberts of Shiloh Baptist Church are seen here in Atlantic City, with Juanita Sims kneeling and taking their picture, around 1956. Reverend Roberts was closely linked with legendary gospel singer Mahalia Jackson. (Photograph by John Mosley; courtesy of Charles L. Blockson Afro-American Collection, Temple University.)

Henrietta Wallace poses in the sand on Chicken Bone Beach as she relaxes and enjoys the sun in the 1960s. In the background is the million-dollar pier with a Ferris wheel ride and family entertainment. (Courtesy of Henrietta Wallace Shelton.)

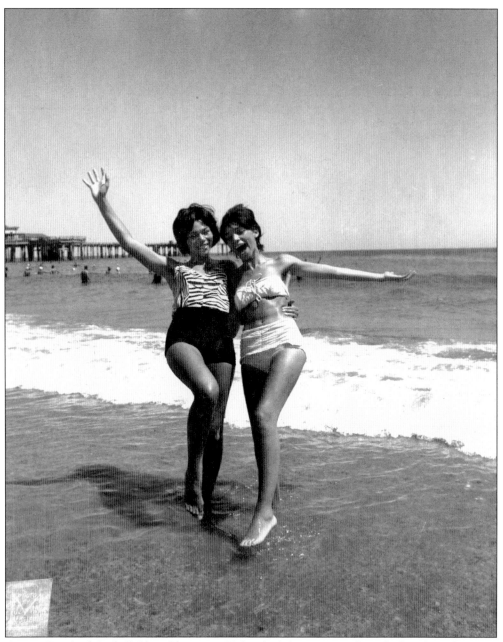

Actress Rosalind Cash (left) and her sister Helen (right) are pictured on the beach in the water holding one foot up as a small wave of water splashes on the sand. They are sharing happy moments. (Photograph by John Mosley; courtesy of Charles L. Blockson Afro-American Collection, Temple University.)

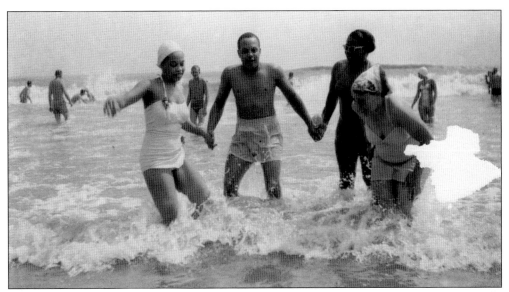

Having fun in the water are, from left to right, family friend Kitty, Tommy Stanback, Mary Belle Stanback, and Mary Etta Donfor in Atlantic City around 1952. (Courtesy of Charlene Donfor.)

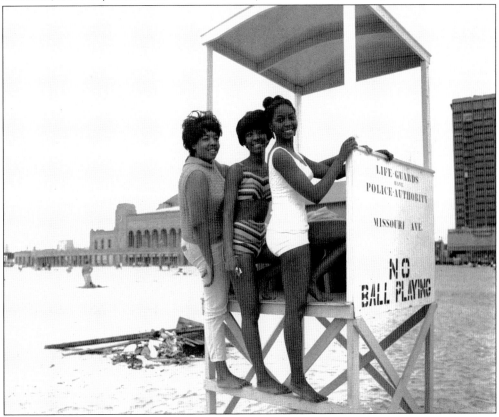

Standing on the lifeguard stand with Convention Hall in the background, these women may have purchased this souvenir photograph from John Mosley. (Photograph by John Mosley; courtesy of Charles L. Blockson Afro-American Collection, Temple University.)

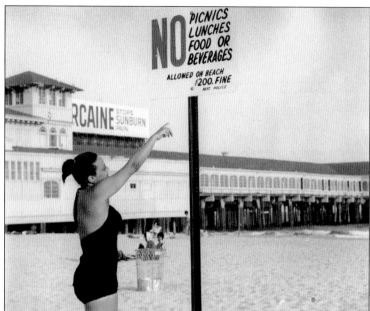

Over time, the city passed various laws restricting activity on the beach. For a time, no picnicking was permitted. (Photograph by John Mosley; courtesy of Charles L. Blockson Afro-American Collection, Temple University.)

Eventually, other ordinances were relaxed, and people now even wear swimsuits on the Boardwalk. African American visitors and residents were welcomed into all beachfront businesses. Shown here is the entrance to Missouri Avenue Beach. (Photograph by John Mosley; courtesy of Charles L. Blockson Afro-American Collection, Temple University.)

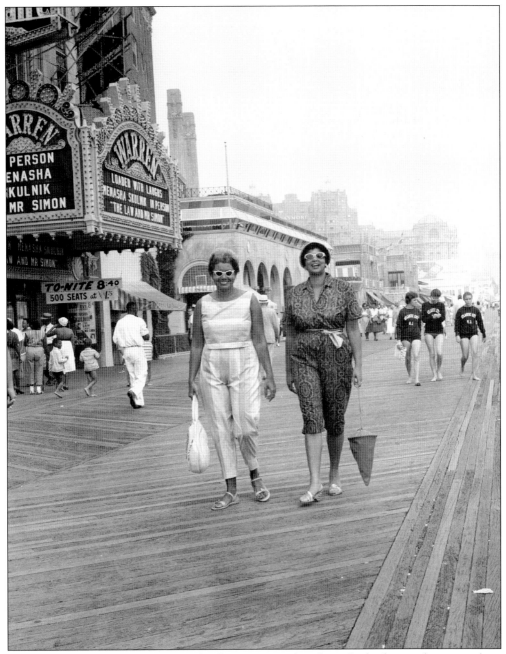

Here, two women walk on the Boardwalk in pants with girls in the background wearing short shorts. (Photograph by John Mosley; courtesy of Charles L. Blockson Afro-American Collection, Temple University.)

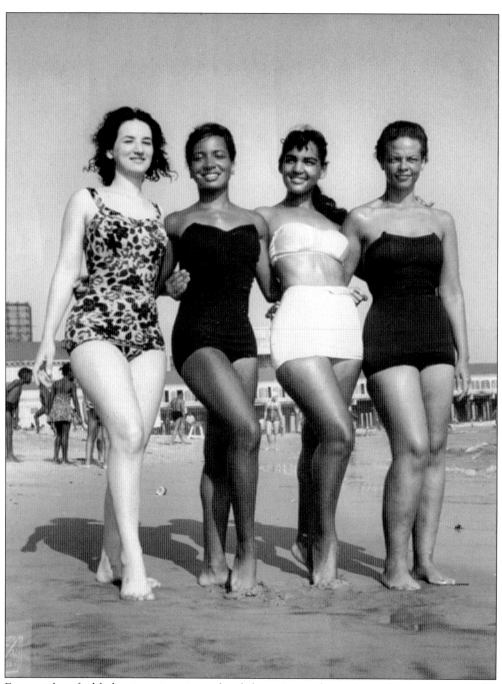

Four unidentified ladies in swimsuits smile while posing and enjoying a day in the sun at the beach. Black women were known for being photographed and showcasing their beauty during outdoor events. These ladies are wearing different swimsuit outfits representing different shades of black beauty. (Photograph by John Mosley; courtesy of Charles L. Blockson Afro-American Collection, Temple University.)

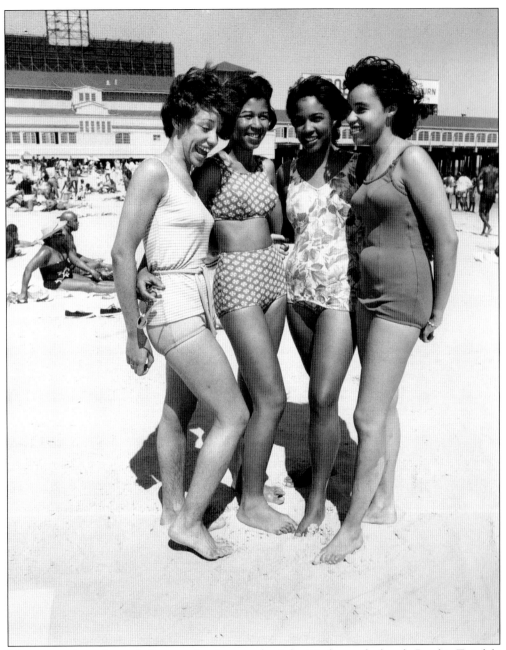

More swimsuits and more ladies pose for photographer John Mosley on the beach. Peachie Twisdale is on the far left. (Photograph by John Mosley; courtesy of Charles L. Blockson Afro-American Collection, Temple University.)

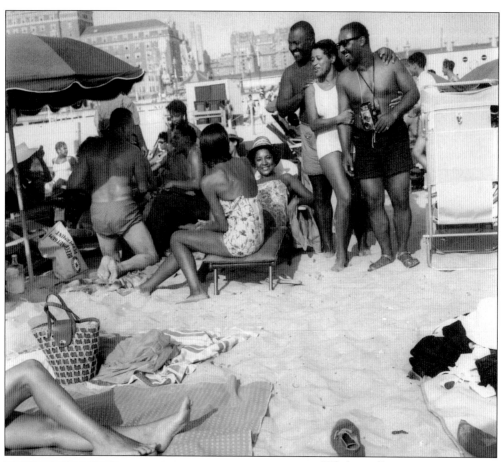

While strolling past a group of men and women under umbrellas and relaxing on lawn chairs on the beach, this photographer and his friends all of a sudden found themselves the subject of the photograph instead. (Photograph by John Mosley; courtesy of Charles L. Blockson Afro-American Collection, Temple University.)

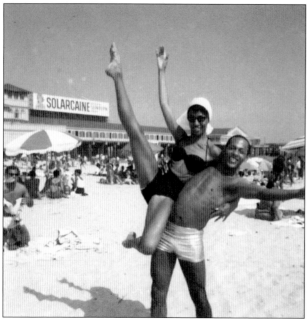

Donald Fontaine (dancer Lon Fontaine's brother) is holding Joan Meyers Brown in his arms as she illustrates a dancer's flair during her time off on the beach. (Courtesy of Joan Meyers Brown.)

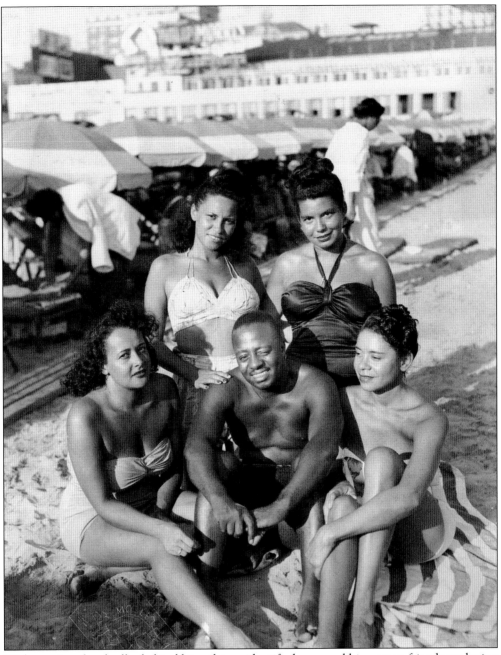

With a series of umbrellas behind him, this unidentified man and his women friends are loving the sun and sandy beach fun. (Photograph by John Mosley; courtesy of Charles L. Blockson Afro-American Collection, Temple University.)

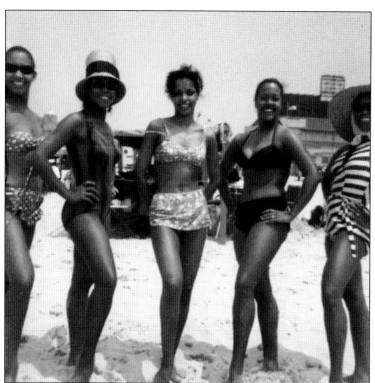

From left to right are dancers JoAnn Jolly, Juanita Jones, Betty Clark, Jackie Dais, and unidentified from Larry Steele's *Smart Affairs* revue enjoying the beach during their down time. (Courtesy of Joan Meyers Brown.)

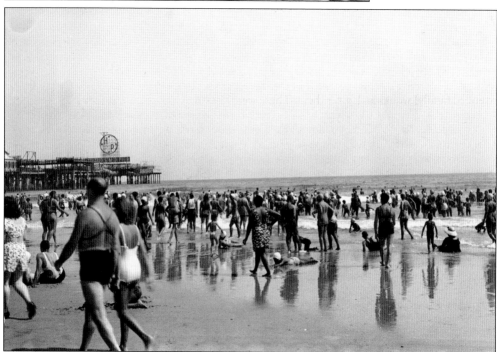

As time went by, Missouri Avenue became a popular central location for people of all races to enjoy the beach. (Photograph by John Mosley; courtesy of Charles L. Blockson Afro-American Collection, Temple University.)

Four

The Chicken Bone Beach Historical Foundation Inc.

The local citizens used the beach as a place not only to catch up on the latest community news, but also to network and make business connections. The children could be left on the beach during the day without their parents because neighbors and the entire community (or the Black extended family) would look after them. These were the times and the social conditions that led to the rise and decline of the beach, and the establishment of the Chicken Bone Beach Historical Foundation Inc. in 1997. The mission of this 501(c)3 nonprofit organization is to promote pride in the history of the Northside Atlantic City African American community by preserving and celebrating family values and unity through its annual summer Jazz on the Beach concert series.

The Chicken Bone Beach Historical Foundation Inc. serves as an integral cornerstone of the community through the development of annual summer jazz concerts by recognizing the contributions of New Jersey jazz artists and the impact they have made on the culture of Atlantic City. The organization recently obtained funding to sustain its annual summer jazz concerts and, through the support of city and state government officials, renovated an old house donated by Wells Fargo Bank and turned it into the Youth Institute for Jazz Studies, which provides instructions from professional jazz artists and musicians to local students.

The organization and its contributions to the city, region, and the nation have left a legacy of jazz that links the history of the beach to the younger generation. In 1997, the Atlantic City Council passed an ordinance declaring Chicken Bone Beach a historical landmark. The ordinance was initiated and promoted by the Chicken Bone Beach Historical Foundation Inc. under the leadership of Henrietta Shelton. Over the years, the efforts of the organization have been supported by Atlantic City, Atlantic County, the Casino Reinvestment Development Authority, and generous contributions from businesses and the public.

Chicken Bone Beach was designated as an Atlantic City historical landmark in 1997, honoring the lifeguards who patrolled the beach area. Chicken Bone Beach and its role in American history brought laughter and joy to thousands of vacationing African Americans who flocked to the shore annually. Traveling from different East Coast cities and states annually during the Jim Crow era from 1900 to late 1950s, African Americans were socially restricted to the Missouri Avenue Beach. The dedication gave recognition to the historical memory of Chicken Bone Beach and its survival as a symbol of family unity and African American brotherhood and sisterhood. Thanks to Atlantic City mayor Don Guardian and six councilmen, a new Chicken Bone Beach sign was installed in 2015 to tell the story of the historic beach. The wooden-framed plaque near the beach now reads: "This beach was designated the exclusively African American section of the beach in the segregated era. The nickname, Chicken Bone Beach, was derived from visitors bringing baskets of fried chicken to the beach. The beach attracted popular Black entertainers, local residents and tourists. With the passage of the 1964 Civil Rights Act, all Atlantic City beaches were open to everyone." (Left, photograph by Nick Ganaway; below, photograph by Rosemarie Mosteller.)

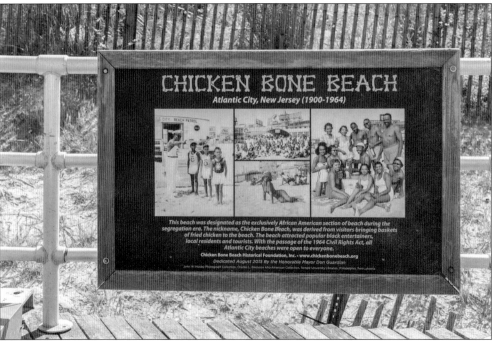

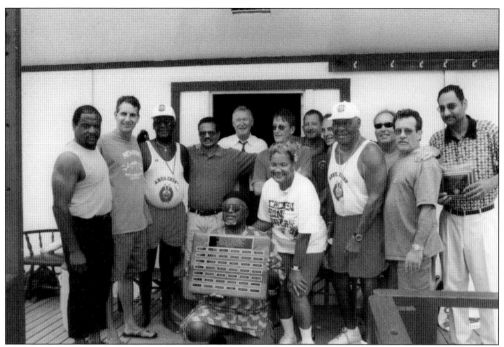

Twelve of the 41 Chicken Bone Beach lifeguards from the Atlantic City Beach Patrol gathered in 1997 for the dedication of the beach as a historical landmark. (Courtesy of Henrietta Wallace Shelton.)

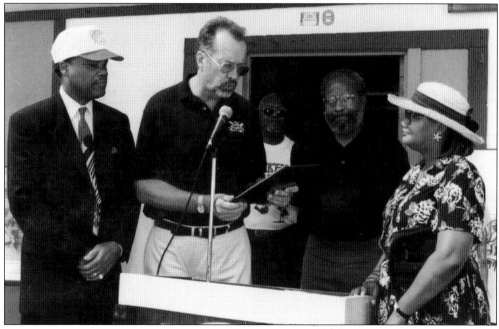

Mayor James Whelan presented Chicken Bone Beach Historical Foundation cofounders Gene Wallace (left) and Henrietta Shelton (right) with the historical landmark designation in 1997. In the background are, from left to right, Cecil Callender (treasurer) and Giles Wright from the New Jersey Historical Commission witnessing the official recognition. (Courtesy of Henrietta Wallace Shelton.)

The CHICKEN BONE BEACH HISTORICAL FOUNDATION
proudly presents a Sneak Preview
of next years

SUNSET JAZZ ON THE BEACH

CONCERT SERIES

LEGENDARY JAZZ, POP, FUNK, SOUL & R&B

VIBRAPHONIST

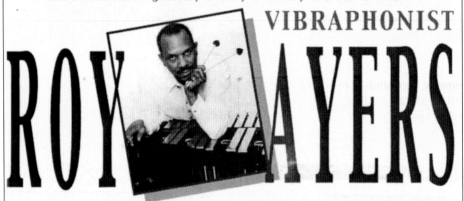

ROY AYERS

& UBIQUITY

Thursday, August 31st -- 6pm - 9pm
on Historic Chicken Bone Beach, Atlantic City, NJ
(between Missouri & Mississippi -- next to Ocean One Mall)

plus
Extra Added Attraction...Atlantic City Saxophonist

HASSAN ABDULLAH & His Quintet

This Concert Is Presented **FREE!...FREE!...FREE!**

Funded in part by NJ State Council of the Arts/Department of State thru the Atlantic County Office of Cultural & Heritage Affairs, Bally's Park Place Casino, Caesars Atlantic City, Hilton Casino, Borgata, the City of Atlantic City and the Atlantic City Convention & Visitors Authority

The first jazz concert presented by the Chicken Bone Beach Historical Foundation was with Roy Ayers in 2000. (Courtesy of Henrietta Wallace Shelton.)

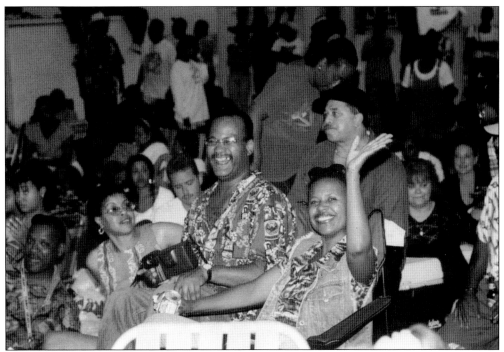

Concertgoers attend the 2000 Roy Ayers Jazz Concert on the beach, which was the first concert sponsored by the Chicken Bone Beach Historical Foundation Inc. On the beach as well as on Boardwalk, thousands of people enjoyed the concert. (Courtesy of Henrietta Wallace Shelton.)

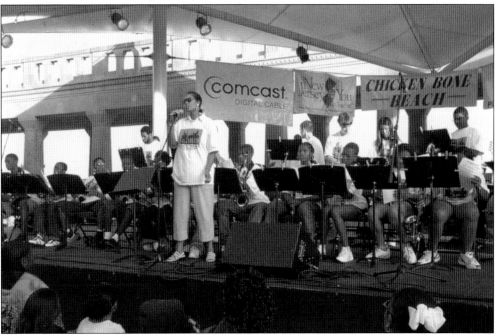

The students at the Summer Jazz Camp perform on the Boardwalk in 2005. The camp was started by Cynthia Primas (at the microphone) and Donald Byrd to expose local students to jazz music and instruments. (Photograph by David Goodman; courtesy of Henrietta Wallace Shelton.)

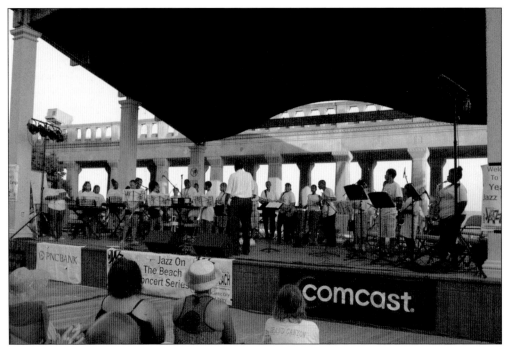

At the 2012 Summer Jazz Camp, students perform with program director Joe Brown. The students opened up for famous headliner jazz artists Oden Pope, Tim Warfield, Webb Thomas, and many others. The students showcased their skills during the 13th annual jazz concert. After three weeks of intense practicing, a student piano soloist (below) opened up the 2012 Summer Jazz Camp jams on the Boardwalk. (Both photographs by David Godman; courtesy of Henrietta Wallace Shelton.)

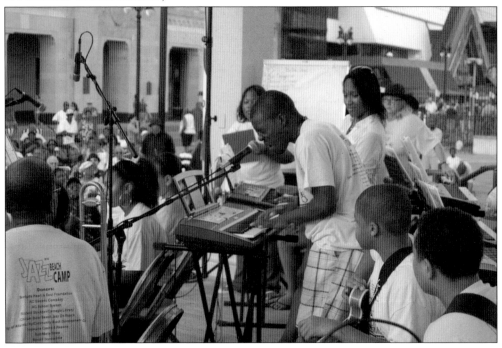

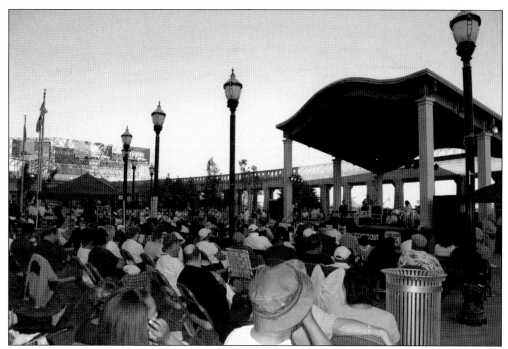

Crowds on the Boardwalk enjoy the annual Jazz on the Beach concerts in 2010. Jazz artists Ralph Peterson Jr., Avery Sharpe, John Blank Jr., and Tim Warfield headlined the summer event. (Photograph by David Goodman; courtesy of Henrietta Wallace Shelton.)

Dave Valentin (left) and emcee Dave Goodman (right) are pictured at a 2011 Chicken Bone Jazz Concert. (Courtesy of Henrietta Wallace Shelton.)

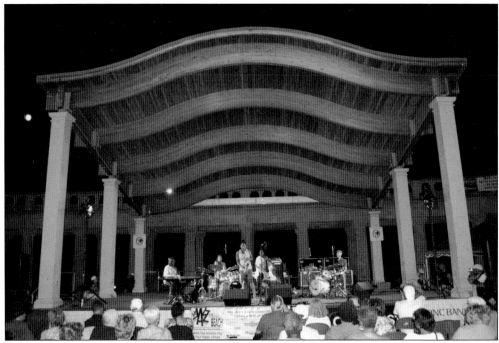

Saxophonist Tia Fuller performs before a large crowd in 2011 at Kennedy Plaza Stage on the Boardwalk during the 12th annual jazz concert. (Photograph by David Goodman; courtesy of Henrietta Wallace Shelton.)

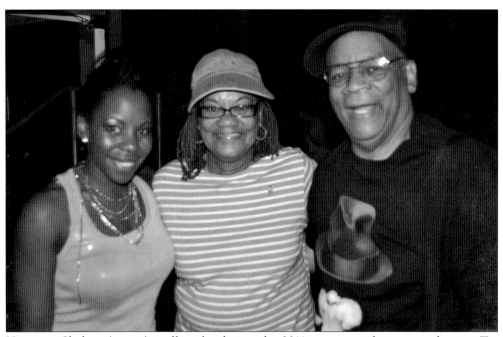

Henrietta Shelton (center) is all smiles during the 2011 concert with jazz saxophonists Tia Fuller (left) and Bootsie Barnes (right). (Photograph by David Goodman; courtesy of Henrietta Wallace Shelton.)

In this 2002 photograph, the Charles Fambrough Quintet jams at the jazz series. Fambrough, an American jazz bassist and composer from Philadelphia, performed with Art Blakely during the early 1980s. (Photograph by David Goodman; courtesy of Henrietta Wallace Shelton.)

Jazz vibraphonist Stefon Harris (left) performed at Jazz on the Beach in 2006. Here, he poses with Henrietta Shelton (right) at the event. Stefon Harris is a talented musician and composer with an impressive track record as an instructor of jazz education. (Photograph by David Goodman; courtesy of Henrietta Wallace Shelton.)

Jazz on the Beach staff sells concessions at the concert. From left to right are Nigaria Garcia, Aaron Garcia, and Jamal Walker. (Photograph by David Goodman; courtesy of Henrietta Wallace Shelton.)

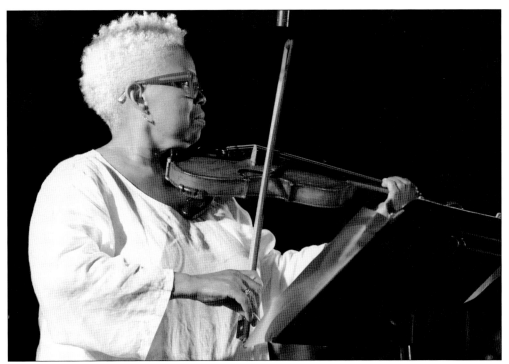

Regina Carter plays the violin with the Helen Sung Quartet on August 25, 2022. The famous Regina Carter, a jazz master, wowed the crowd as she performed a solo. (Photograph by David Goodman; courtesy of Henrietta Wallace Shelton.)

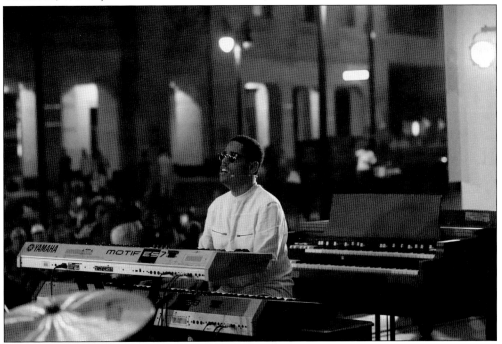

Matthew Whitaker, a keyboardist who is visually impaired, performs at Jazz on the Beach in 2022. (Photograph by David Goodman; courtesy of Henrietta Wallace Shelton.)

Above, Matthew Whitaker jams on the organ and keyboard at the 2022 Jazz on the Beach concert. Whitaker, who is blind, is an American jazz artist. He began performing at the age of 10 years old. The crowds enjoyed the concert. Below, sound engineers from Zeo Brothers Production Company run the show. Zeo Brothers has been the sound production company for the Chicken Bone Beach jazz concerts for 21 years with the support of Barry Painter, who is not shown. (Both, photographs by David Goodman; courtesy of Henrietta Wallace Shelton.)

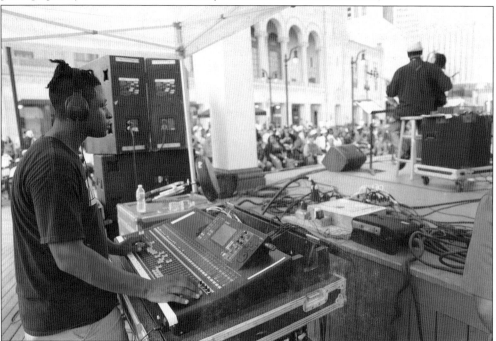

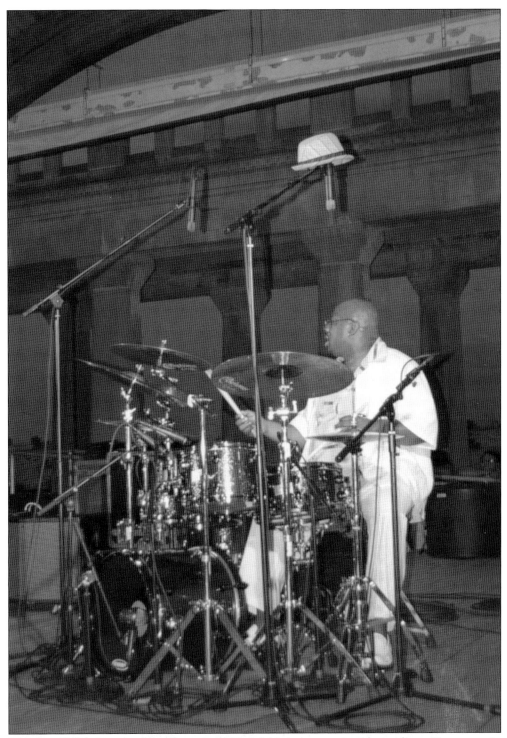

Drummer Ralph Peterson Jr. performs in 2002 with his hat on a microphone above. He grew up in nearby Pleasantville, New Jersey, and his father was the mayor. (Photograph by David Goodman; courtesy of Henrietta Wallace Shelton.)

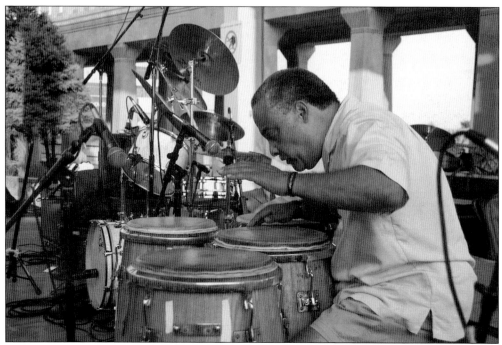

Isaac Nicholson, the Chicken Bone Beach music director in 2012, is seen here playing with Dwain Davis Quartet. (Photograph by David Goodman; courtesy of Henrietta Wallace Shelton.)

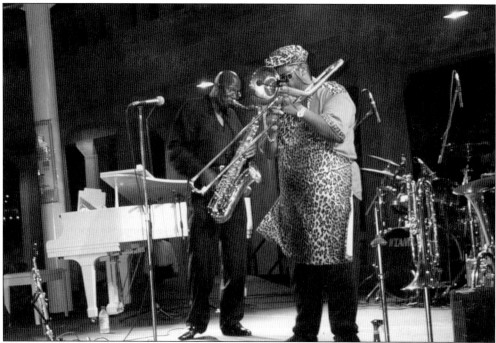

The Jazz Crusaders, with Wayne Henderson on trombone and Wilton Felder on sax, perform at a 2001 concert. (Photograph by David Goodman; courtesy of Henrietta Wallace Shelton.)

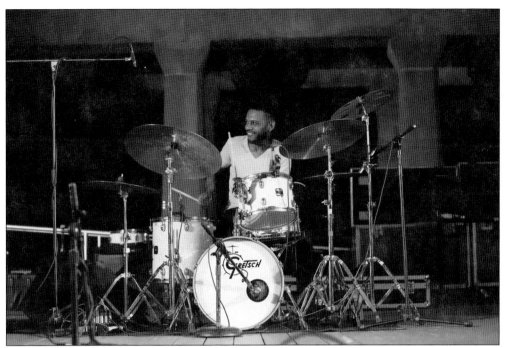

This drummer is all smiles doing a good drum solo. Drum solos are impressive feats of display and excitement. For drummers, they require concentration, incredible control, and a good drummer behind the drum set. (Photograph by David Goodman; courtesy of Henrietta Wallace Shelton.)

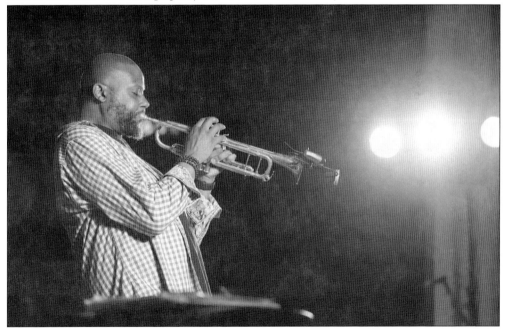

Taking his trumpet in triumph for this musical act, Sean Jones performs a solo after dark at the Jazz on the Beach concert in 2014. Trumpeter Jones was featured on Nancy Wilson's 2007 Grammy Award–winning album *Tune to Blue*. (Photograph by David Goodman; courtesy of Henrietta Wallace Shelton.)

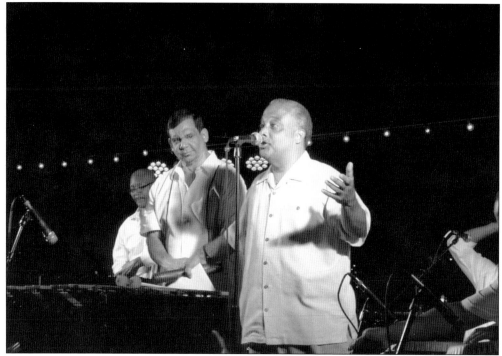

Isaac Nicholson, Chicken Bone Beach music director, accepts a gift from the Steve Pouchie Latin Quartet when they played at the Jazz in the Park series in 2015. (Photograph by David Goodman; courtesy of Henrietta Wallace Shelton.)

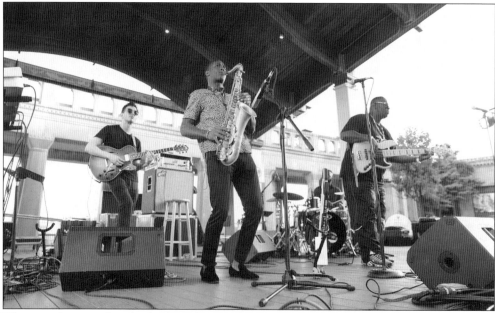

This saxophonist takes the lead on this number. Mastering the sound of the saxophone, this regional musical performer aided in pleasing the crowds through sound, style, and presentation. The saxophone, like the trumpet, is an iconic instrument in jazz. (Photograph by David Goodman; courtesy of Henrietta Wallace Shelton.)

Marc Cary Trio performs at the 2012 Jazz Series at Dante Hall. Cary, a pianist, focuses on post-bop jazz music and has played with performers like Dizzy Gillespie, Betty Carter, and Roy Highgrove. (Courtesy of Henrietta Wallace Shelton.)

Philadelphia jazz vocalist Ella Gahnt performs a soaring number. Showcasing arguably the oldest and most personal musical instrument of them all—the human voice— Gahnt displayed an overwhelming amount of talent by sharing an array of storied history through her voice. (Photograph by David Goodman; courtesy of Henrietta Wallace Shelton.)

Helen Sung, a jazz pianist, rocks this number. She is a native of Houston, Texas, and has performed for the Chicken Bone Beach Jazz on the Beach Concert Series on numerous occasions. Here, her piano was played with grace, style, and charm. Sung attended the University of Texas at Austin and earned undergraduate and master's degrees in classical piano performance. Sung has performed with jazz greats Herbie Hancock, Wayne Shorter, Clark Terry, Slide Hampton, Ron Carter, Jon Faddis, T.S Monk, MacArthur Fellow, and Regina Carter. For Jazz on the Beach, the audience stays into the evening for the cool jazz sounds, as seen below. (Both, photographs by David Goodman; courtesy of Henrietta Wallace Shelton.)

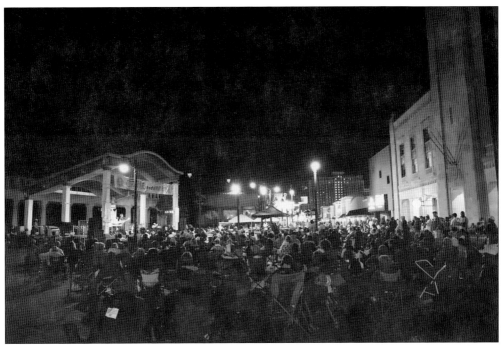

The weekly crowd fills the Boardwalk between Kennedy Plaza and Boardwalk Hall during the evening concert performances. (Photograph by David Goodman; courtesy of Henrietta Wallace Shelton.)

Latin jazz conga player Wilson "Chembo" Corniel pounds his LP Galaxy Giovanni drums. Corniel was nominated for a 2005 Grammy Award. Appearing wild and frantic, conga-playing musicians typically perform beats using a tall, narrow single-headed Cuban drum, which has an African origin known as the *tumbadora*, or conga as it is internationally recognized. While the African drums are made from hollowed logs, the Cuban conga is staved from ribs like a barrel or shaped from one solid piece like a hollowed log. (Photograph by David Goodman; courtesy of Henrietta Wallace Shelton.)

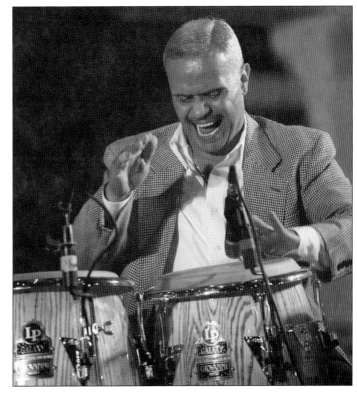

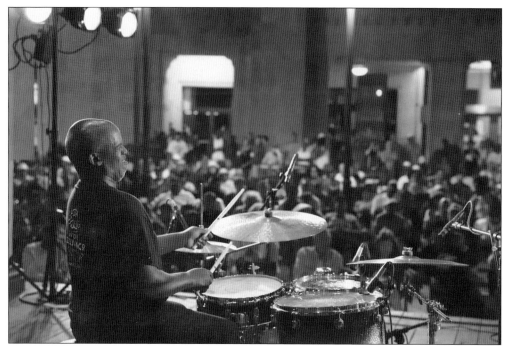

Overlooking the crowd in front of Boardwalk Hall, this drummer is really into the beat. Drum solos are all about build up, tension, and release. Captivating the audience while showcasing his own style, this drummer won them over as he had the crowds on their feet waiting with anticipation. (Photograph by David Goodman; courtesy of Henrietta Wallace Shelton.)

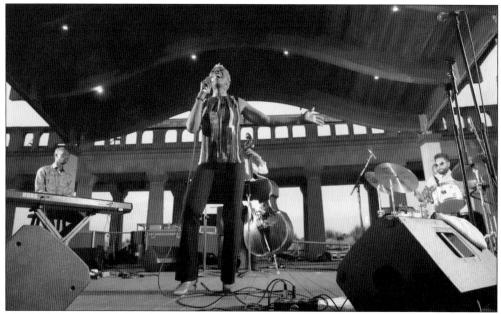

Jazz on the Beach includes all-instrumental performances as well as vocalists. Vocalists captivate the crowds with their soaring vocals and their stage presence, while the instrumentalists accompany and support their performances. (Photograph by David Goodman; courtesy of Henrietta Wallace Shelton.)

From left to right are Chicken Bone Beach volunteer Viola Hudgins, jazz camp director Cynthia Primas, and Chicken Bone Beach Historical Foundation Inc. president Henrietta Shelton. (Photograph by David Goodman; courtesy of Henrietta Wallace Shelton.)

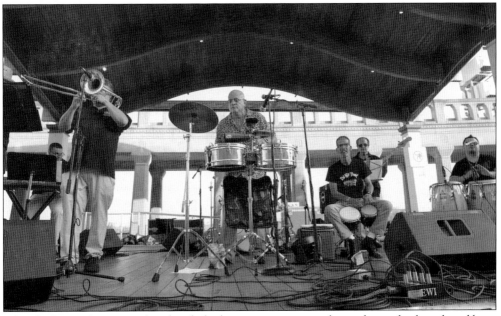

Edgardo Cintron's six-piece band includes bongos, congas, trombone, drums, keyboard, and bass. (Photograph by David Goodman; courtesy of Henrietta Wallace Shelton.)

These concertgoers could not stand still, dancing and enjoying the Latin beats and sounds of the music on the Boardwalk. (Photograph by David Goodman; courtesy of Henrietta Wallace Shelton.)

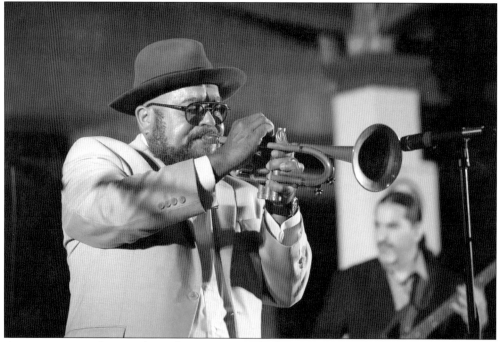

A jazz trumpeter does a solo at this concert as the bass prepares to back him up. The bright sounds of the trumpet, which are prevalent in jazz music, carry through the night at the Jazz on the Beach concerts each summer. (Photograph by David Goodman; courtesy of Henrietta Wallace Shelton.)

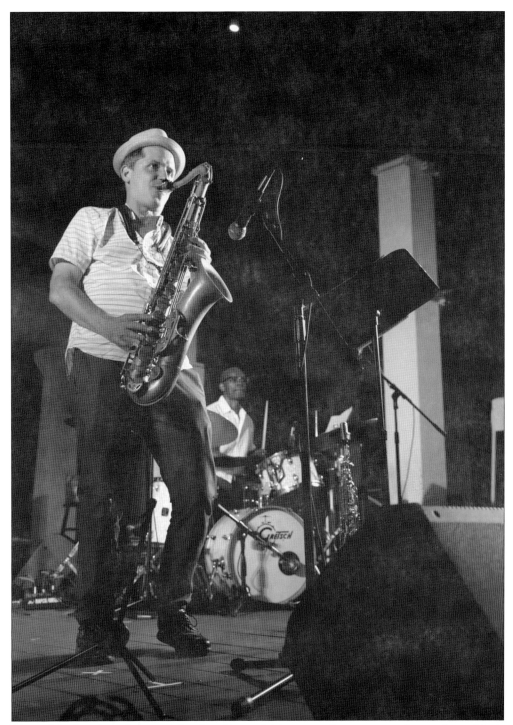

Most of the bands perform straight-ahead jazz, which means they create as they perform. Music historians refer to this form of creative jazz as improvisation, which represents "real jazz." The jazz community has produced an impressive list of jazz masters over the course of the past 100 years. (Photograph by David Goodman; courtesy of Henrietta Wallace Shelton.)

Counting the money at the 2005 fundraiser auction on Garden Pier, are, from left to right, Pamela Alleyne, Barbara Brown, and former CBBHFI vice president Jim Zombeck. (Courtesy of Henrietta Wallace Shelton.)

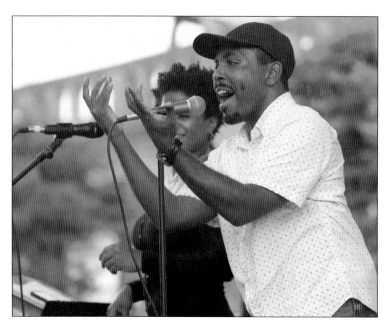

Bands come from all over the region to perform, including this one from Camden, New Jersey, in which the vocalist performs with great gestures. (Photograph by David Goodman; courtesy of Henrietta Wallace Shelton.)

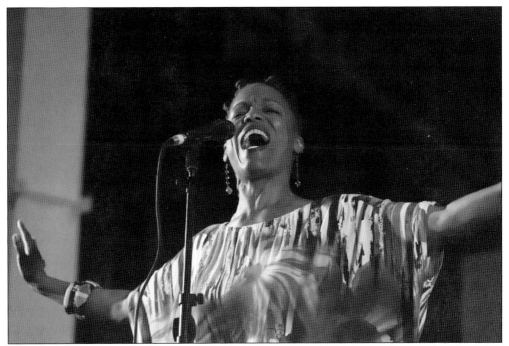

This vocalist delivers an expressive performance. Hitting a high note, she stretches forth her arms and shows that she is enjoying the concert as much as the audience. (Photograph by David Goodman; courtesy of Henrietta Wallace Shelton.)

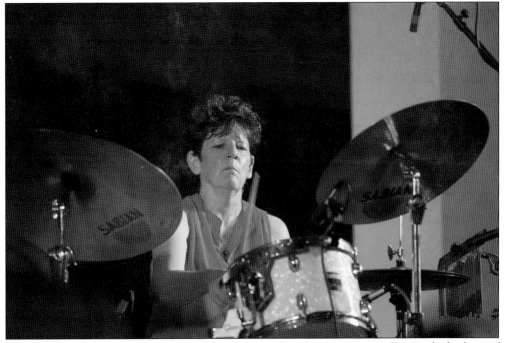

This female drummer concentrates as she performs. Jazz drummers typically match the beat of the drum to the rhythm of the music, employing snare drums, bass drums, cymbals, and high hats. (Photograph by David Goodman; courtesy of Henrietta Wallace Shelton.)

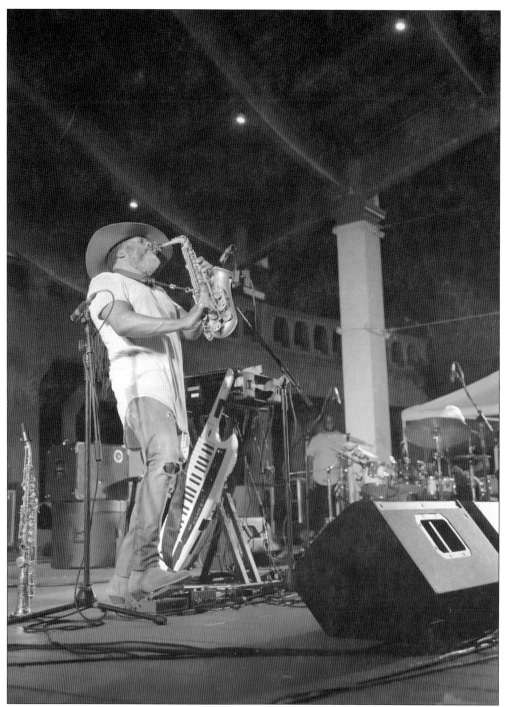

A great saxophonist hones his craft with his tenor saxophone as the night falls—and the crowds love it. Many talented jazz musicians play multiple instruments. Note the different instruments on the stage, like the soprano saxophone (left) and the handheld electric keyboard (right). American jazz pianist Herbie Hancock made this type of keyboard famous. (Photograph by David Goodman; courtesy of Henrietta Wallace Shelton.)

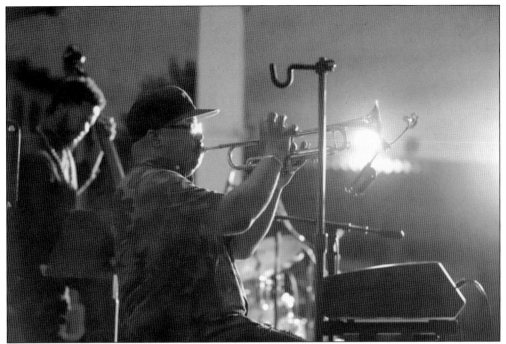

Grammy Award–winning trumpeter Nicholas Payton blows into the night as the bass player reinforces. The New Orleans native won the 1997 award for Best Instrumental Solo for his work on the album *Doc Cheatham & Nicholas Payton*. (Photograph by David Goodman; courtesy of Henrietta Wallace Shelton.)

Chicken Bone Beach renovated this dilapidated house on North Indiana Avenue with funds from the City of Atlantic City Community Development Block Grant, the Casino Reinvestment Development Authority (CRDA), and private donors. (Photograph by Cortez Martin; courtesy of Henrietta Wallace Shelton.)

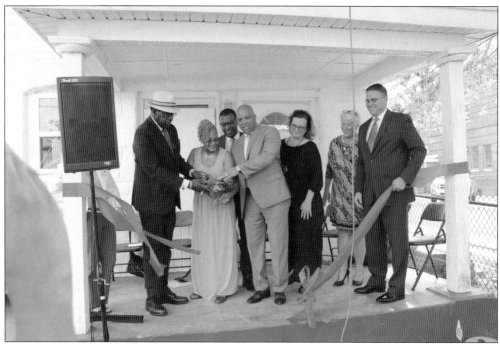

Once renovated, the house became the CBBHFI Youth Institute for Jazz Studies. City and state officials and Chicken Bone Beach (CBB) board members attend the ribbon cutting. From left to right are Councilman Kaleem Shabazz, CBB founder and president Henrietta Shelton, Atlantic City state liaison James Johnson, Atlantic City mayor Frank Gilliam, CBB board member Lisa Honaker, Stockton University interim provost Michelle McDonald, and Matt Doherty, executive director of CRDA. (Photograph by Cortez Martin; courtesy of Henrietta Wallace Shelton.)

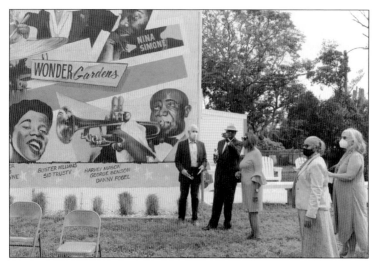

At the dedication of the institute in 2021 are, from left to right, Jack Plackter, Esq.; Atlantic City councilman Kaleem Shabazz; New Jersey State lieutenant governor Sheila Oliver; Henrietta Shelton; and Lisa Honaker with other CBB board members. (Photograph by Cortez Martin; courtesy of Henrietta Wallace Shelton.)

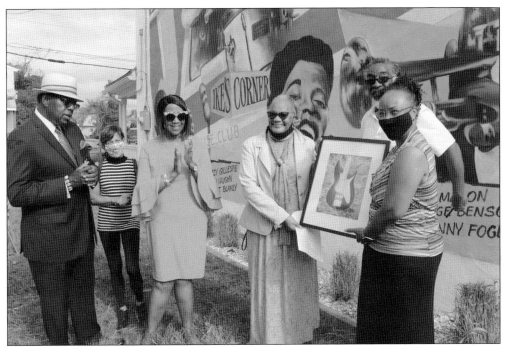

Nancy Sorden-Cobb gifts a hand-drawn picture for the CBBHFI Youth Institute for Jazz Studies, commissioned by longtime supporter Derek Cason. Pictured are, from left to right, Councilman Kaleem Shabazz, Dr. Laurie Greene, New Jersey lieutenant governor Sheila Oliver, Henrietta Shelton, Cason, and Sorden-Cobb. (Photograph by Cortez Martin; courtesy of Henrietta Wallace Shelton.)

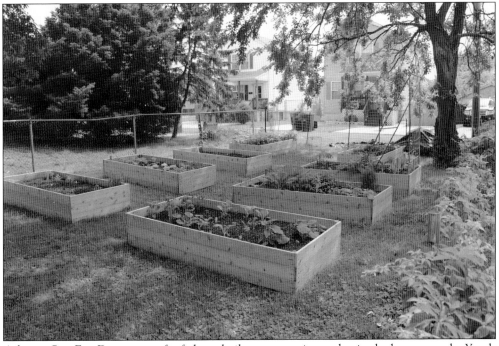

Atlantic City Fire Department firefighters built a community garden in the lot next to the Youth Institute for Jazz Studies. (Photograph by Cortez Martin; courtesy of Henrietta Wallace Shelton.)

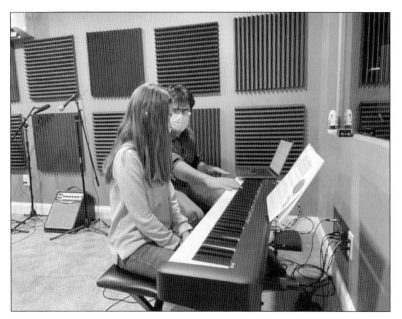

A piano student at the CBBHFI Youth Institute for Jazz Studies takes a class from instructor Miles Smith. (Courtesy of Henrietta Wallace Shelton.)

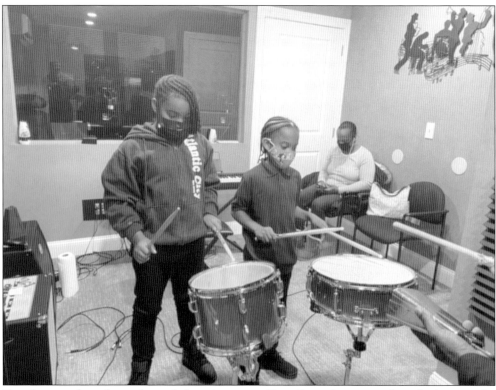

Two drum students learn the craft from instructor Tony Day, who is providing the beat on the cowbell in the lower right. (Courtesy of Henrietta Wallace Shelton.)

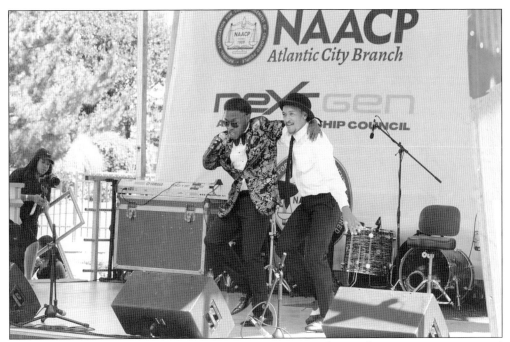

Reenactors performed for the 2022 NAACP Convention Conference during a concert sponsored by Chicken Bone Beach Historical Foundation Inc. Here, Isaiah Robinson (left) portrays Sammy Davis Jr. and Arthur Leo Taylor (right) portrays Larry Steele. (Photograph by Edward Lea.)

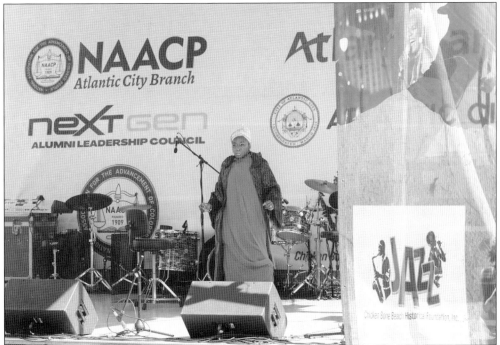

Imitating the sounds and style of Nina Simone, who performed in Atlantic City in the 1950s, Shawnta Smith-Taylor enthralls the crowds at the 2022 NAACP concert. (Photograph by Edward Lea.)

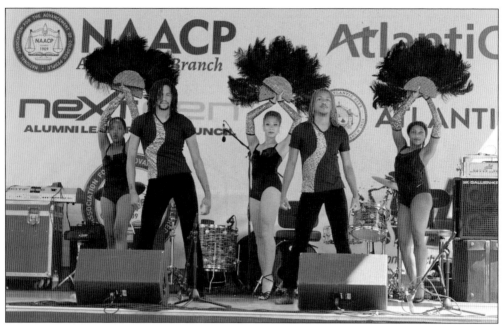

Fan dancers perform to the music of yesteryear, giving the 2022 NAACP concert a sample of entertainment from the Club Harlem era. Reenactors included, from left to right, Mikayla Nelson, Robert Burden, Courtney Robinson, William Burden, and Viola Taylor. (Photograph by Edward Lea.)

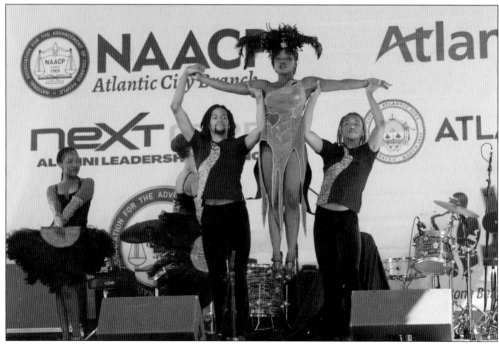

Acrobatics and lifts are all part of the reenactors' performance. Here, Rhapsody Taylor (center), portraying dancer Lola Falana, is lifted by Robert Burden and William Burden during the show. (Photograph by Edward Lea.)

A four-piece band plays straight-ahead jazz for the crowd at the concert. On the piano is Nat Adderley Jr. (Photograph by Edward Lea.)

The crowd at the 2022 NAACP Chicken Bone Beach concert dances along to the sounds and takes pictures. (Photograph by Edward Lea.)

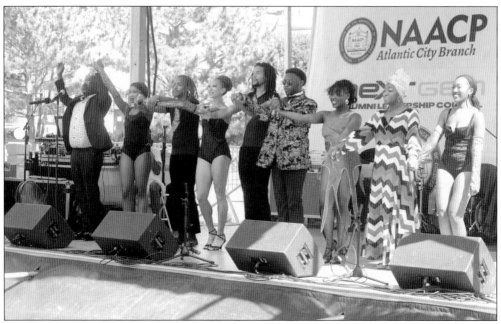

Taking their bows, the reenactors from Arthur Taylor's ensemble portrayed artists who performed in Atlantic City in days gone by. (Photograph by Edward Lea.)

As part of the 2022 NAACP Convention Conference concert, attendees visit the site of Historic Chicken Bone Beach. (Photograph by Edward Lea.)

Some of the CBBHFI board members seen here are, from left to right, Henrietta Shelton, Michael Johnson, Keturah Jackson, Cortez Martin, and Derek Longcrier after a concert on August 25, 2022. (Photograph by David Goodman; courtesy of Henrietta Wallace Shelton.)

Former members of the CBBHFI Board of Directors Mac and Louise Henderson enjoy a 2012 concert at the top of the Tropicana Hotel Casino. (Courtesy of Henrietta Wallace Shelton.)

Dedicated volunteers collect money, sell merchandise, and help in other ways. Pictured here are, from left to right, Judith Lokich, Henrietta Shelton, and Barbara Brown. (Courtesy of Henrietta Wallace Shelton.)

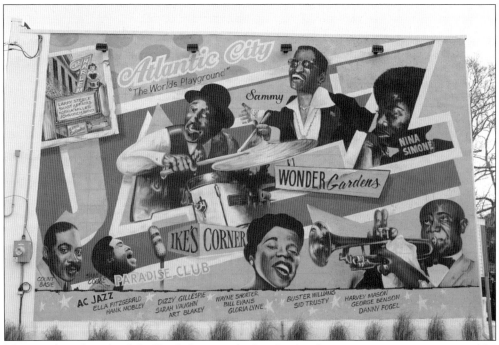

The mural on the side of the Youth Institute for Jazz Studies featuring jazz greats was painted by Glenn Taylor. (Photograph by Cortez Martin; courtesy of Henrietta Wallace Shelton.)

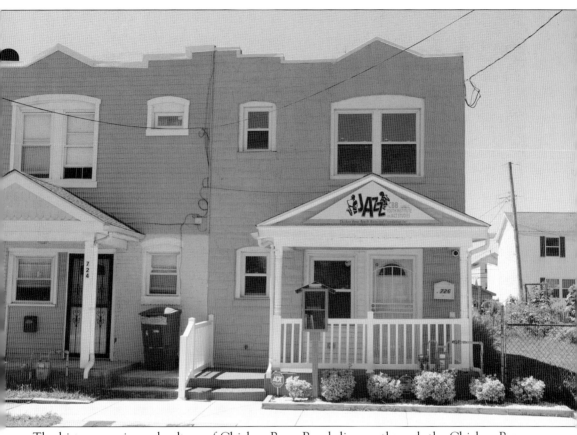

The history, music, and culture of Chicken Bone Beach live on through the Chicken Bone Beach Historical Foundation Inc. Concerts, music lessons, exhibits, and more serve to remind the community of its rich heritage. (Photograph by Cortez Martin; courtesy of Henrietta Wallace Shelton.)

Chicken Bone Beach Historical Foundation, Inc.

Theo Primas wrote the following poem, which has been featured on the Chicken Bone Beach Historical Foundation's merchandise. (Courtesy of Theo Primas.)

"Chicken Bone Beach
Atlantic City, New Jersey"©

A.C. . . . The world's playground
before the casinos,
before the marches and the sit-ins
When Jim Crow ruled the land and segregation was the word,
Black folks weren't allowed to sit on any beach we chose.
Oh no!
So Missouri Avenue Beach became the place for us
Maybe it was because you could walk there from the bus station…
Where the buses rolled in from New York,
Camden, Philly, Baltimore and D.C.
Missouri Avenue Beach soon became known as
"Chicken Bone"
. . . and it was ours
Black, brown and beige bodies on burning sand and blue surf
Chicken Bone Beach – sure was happenin' had a sound
and rhythm all its own, a cultural oasis, our place in the sun
If you're too young to remember just ask your grand mom or your
Uncle Jim
Go ahead . . . ask them about Chicken Bone Beach and watch
them smile.

BIBLIOGRAPHY

Applebome, Peter. "Our Towns: On the Atlantic City Boardwalk Other Stories Remain to Be Told." *New York Times*. September 23, 2010: A27.

Compian, Felicia. "Once-Segregated Chicken Bone Beach Remains a Valued Historic Site in A.C." *Press of Atlantic City*. February 23, 2013: 1.

D'Amico, Diane. "Campers Learn Discipline, Teamwork and All That Jazz." *Press of Atlantic City*. August 3, 2011: C1.

Davis, Shabria. "Chicken Bone Beach Concert Series Highlights Atlantic City History, Local Talent." *Press of Atlantic City*. July 6, 2011: 8.

Fine, Eric, Mark Melhorn, and Lindsay Scarborough. "July Kicks Off With Free Music on the Atlantic City Boardwalk." *Press of Atlantic City*. May 23, 2003: 17.

Goddard, Richlyn F. *'Three Months to Hurry and Nine Months to Worry': Resort Life for African Americans in Atlantic City, NJ (1850–1940)*. Dissertation. Howard University, 2001.

Jackson, Vincent. "Let the Children Sing: South Jersey Women Establish Children's Choir Hoping Kids Can 'Embrace Something Positive.' " *Press of Atlantic City*. June 15, 2022: 1A.

Johnson, Nelson. *The Northside: African Americans and the Creation of Atlantic City*. Medford, NJ: Plexus Publishing, 2011.

Kent, Bill. "Refusing To Forget The Pain Of Racism." *New York Times*. August 31, 1997: NJ7.

Levi, Vicki Gold. *Atlantic City, 125 Years of Ocean Madness*. New York: C.N. Potter, 1979.

O'Connor, John. "One Last Experience: Chicken Bone Beach Experience Acts as Finale for NAACP Convention in Atlantic City." *Press of Atlantic City*. July 21, 2022: 1A.

Raheem, Turiya S.A. *Growing Up in the Other Atlantic City: Wash's and the Northside*. Bloomington, IN: Xlibris, 2009.

Schurr, Brendan. "Atlantic City to Designate Beach as Historic Site." *Philadelphia Tribune*. August 19, 1997: 5D.

Simon, Bryant. *Boardwalk of Dreams: Atlantic City and the Fate of Urban America*. New York: Oxford University Press, 2004.

Woodruff-Brooks, Cheryl. *Chicken Bone Beach: A Pictorial History of Atlantic City's Missouri Avenue Beach*. Mechanicsburg, PA: Sunbury Press Inc., 2017.

DISCOVER THOUSANDS OF LOCAL HISTORY BOOKS FEATURING MILLIONS OF VINTAGE IMAGES

Arcadia Publishing, the leading local history publisher in the United States, is committed to making history accessible and meaningful through publishing books that celebrate and preserve the heritage of America's people and places.

Find more books like this at
www.arcadiapublishing.com

Search for your hometown history, your old stomping grounds, and even your favorite sports team.